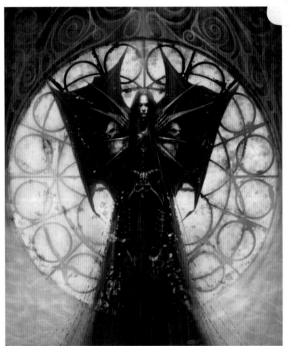

DIGITAL HORROR ART

HOUSE OF FLIES—SAMUEL ARAYA

DIGITAL HORROR ART

CREATE CHILLING HORROR AND MACABRE IMAGERY

MARTIN McKENNA

THOMSON

COURSE TECHNOLOGY

Professional ■ Technical ■ Reference

First published in the United States in 2006 by
Course PTR, a division of Thomson Course Technology.

For Thomson Course Technology, PTR
Publisher and General Manager: **Stacy L. Hiquet**
Associate Director of Marketing: **Sarah O'Donnell**
Marketing Manager: **Heather Hurley**
Acquisitions Editor: **Megan Belanger**
Manager of Editorial Services: **Heather Talbot**
Marketing Coordinator: **Meg Dunkerley**
PTR Editorial Services Coordinator: **Elizabeth Furbish**

ISBN 1-59863-181-0

5 4 3 2 1

Library of Congress catalog card number: 2006923274

Educational facilities, companies, and organizations interested in multiple copies of
this book should contact the publisher for quantity discount information. Training
manuals, CD-ROMs, and portions of this book are also available individually or can
be tailored for specific needs.

Course PTR,
A division of Thomson Course Technology
(www.courseptr.com)
25 Thomson Place
Boston, MA 02210

This book was conceived, designed, and produced by
The Ilex Press Limited
Cambridge
England

Publisher: **Alastair Campbell**
Creative Director: **Peter Bridgewater**
Editorial Director: **Tom Mugridge**
Art Director: **Julie Weir**
Editor: **Kate Shanahan**
Designer: **Tracy Staskevich**
Design Assistant: **Kate Haynes**
Technical Art Editor: **Nicholas Rowland**

Printed in China

CONTENTS

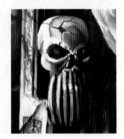

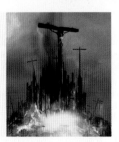

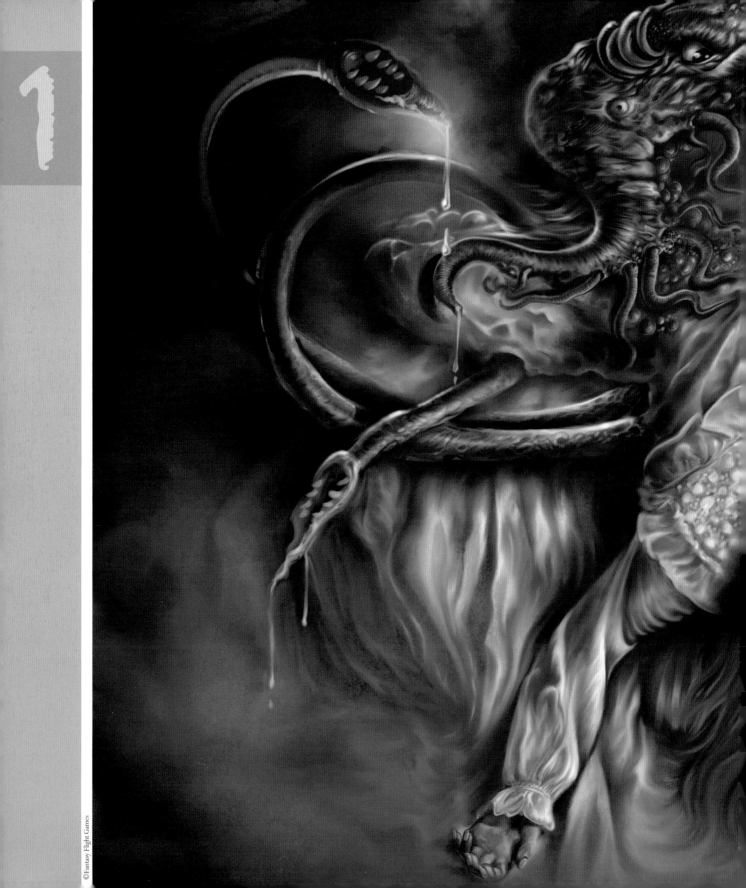

1

AN APPOINTMENT WITH FEAR

Horror art usually has a direct and focused intention: to stir a sense of unease in the viewer, and, with any luck, something that approaches a thrill of terror. The results are confrontational, nightmarish images, playing upon our phobias to provoke a very definite reaction. This kind of art allows us to safely indulge ourselves in the very basic human instinct of fear. Horror pictures provide a passport to the dark side of our nature, where we can explore our age-old inheritance of being afraid of what might lurk in the shadows.

THE THRILL OF TERROR

"**THE OLDEST AND STRONGEST EMOTION** of mankind is fear, and the oldest and strongest kind of fear is fear of the unknown."—H. P. Lovecraft.

Horror images exert a grim fascination. They tell us about what the dark side of our human nature is capable of in both real and imagined forms.

Why do we seek out the experience of fear through horror art? Compared to the horrors of war, starvation, international terror, natural catastrophe, and death in all forms, one might not think that specters from the past such as vampires, ghosts, werewolves, and zombies would make much of an impression today. The answer is that we delight in "safe" scares, interpreting the oppressive and gruesome events of the real world through a dark fantasy world of the supernatural. Although this is of a different nature, it is no less disturbing. The horror artist and viewer are tacitly playing an indulgent game of make-believe; by evoking fears and triggering phobias that can to some extent be exorcised by an artistic convention, they can be experienced esthetically, presented as something both horrible and beautiful.

THE SEAL OF ISIS

SOFTWARE **PHOTOSHOP** ARTIST **TORSTEIN NORDSTRAND**

FAMOUS MONSTERS

Horror imagery has appeared in many and varied forms throughout its long tradition, from the darkly whimsical American Gothic of Charles Addams, to the erotic biomechanical nightmares of H.R. Giger. Images embraced by the genre can be full-blooded and visceral, or convey a sense of haunting supernatural chill. Early horror still holds a great appeal, as is indicated by the continual re-imagined portrayals of characters such as Frankenstein's Creature and Count Dracula who, since they first appeared in 1818 and 1897 respectively, have both become horror icons, clichéd figures to many who have never read Mary Shelley's or Bram Stoker's novels. We identify with these monsters. There is a beauty to them that can inspire both empathy and compassion because, by being the paradigm of inhumanity and disenfranchisement, they illuminate our humanity. Monsters are the ultimate outcasts.

JASON FELIX

"The greatest advantage of working digitally is having the ability to undo whatever marks I make if I dislike them. This makes me more prone to explore, and take chances I would never have taken or felt confident enough to try traditionally. On the other hand, I also find myself getting lost on a piece and I can easily lose my direction if I stray too far from the original idea."

FLESH CRAWL: SOUL SKINNER
SOFTWARE PAINTER ARTIST UWE JARLING

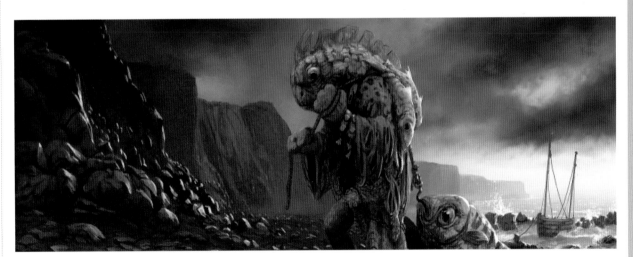

THE FISHERMAN
SOFTWARE PAINTER ARTIST SIMON DOMINIC

1

LEO HARTAS

"Layers are probably the biggest boon in digital painting, allowing infinite flexibility, while Undo reverses minor mistakes. The absolute control and predictability of digital tools helps to speed things up, while sending artwork via the internet adds another couple of days to the deadline. Any good paint program has more tools, media, and possibilities than a well-stocked art shop, although this can also be daunting."

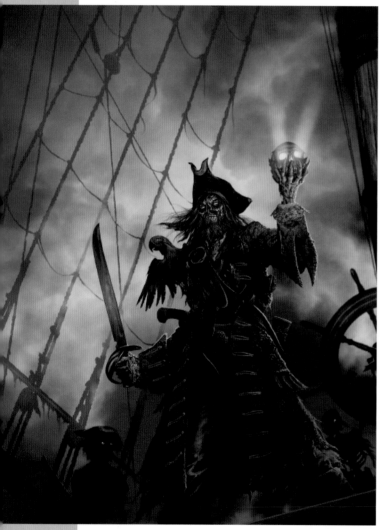

BLOODBONES

SOFTWARE PHOTOSHOP ARTIST MARTIN MCKENNA

A SENSE OF FOREBODING

Playing with the familiar and hackneyed archetypes of schlock-horror imagery can be enormous fun, but attempting more serious horror subjects can present the greatest challenge for a fantasy artist, undertaking the task of depicting our darkest fears without falling foul of cheesy cliché. The uneasy atmosphere and subtle horror conjured in classic ghost stories, such as those masterfully crafted by M.R. James, are among the most difficult dark fantasy subjects to capture visually.

Successful horror art often completes itself in the mind of the viewer, and is done with deft suggestion rather than overworked rendering, so chilling results are achieved with economy. Monster designs can be shown in all their horrific glory, but a greater sense of dread can be captured by rendering them indistinct, obscuring their exact nature.

SOMETHING WICKED THIS WAY COMES

Now, with the latest digital painting and modeling applications, artists are able to realize their nightmare visions in ever more uncannily realistic and frightful depictions. This book demonstrates how some of these digital techniques are used to create horror artwork in a variety of styles. In the company of some of today's leading

SAMUEL ARAYA

"The digital medium opens a vast, mind-boggling realm of possibility. There is just so much that you can do with digital media, without any risk of ruining your work. There's no need to be precious about an image, so you can run amok. And with an organic method of working, you may discover surprising new effects and arrive at results far better than you expected."

digital artists, we'll follow their individual working methods in the creation of horror illustration, comic book art, and computer game and movie production design, from initial sketches to spectacular finished artwork. This book is not intended as a comprehensive guide to the software used, but as a broad overview of the varied techniques employed, to give a rare insight into the inspirations and methodologies that lie behind the work of professional artists and illustrators.

This is a book for anyone interested in creating evocative horror paintings—or for anyone who delights in the frisson of fear evoked by imaginative supernatural horror imagery.

MATT BRADBURY

"The biggest advantage to working digitally is speed. I don't have to prepare a canvas or clean brushes, and I never have to wait for paint to dry. Painting programs allow a great deal of flexibility and freedom and there really isn't a right way or wrong way to work—two artists with the same style of work might achieve that style in very different ways using the same software. The digital medium is also very forgiving, allowing work to be adjusted at any time—one of its greatest advantages over traditional media. On the downside, though, when I've finished a digital painting I don't have anything physical, other than a file on my computer. I can print my work, but it's never the same as having an original painting to display, appreciate, and sell."

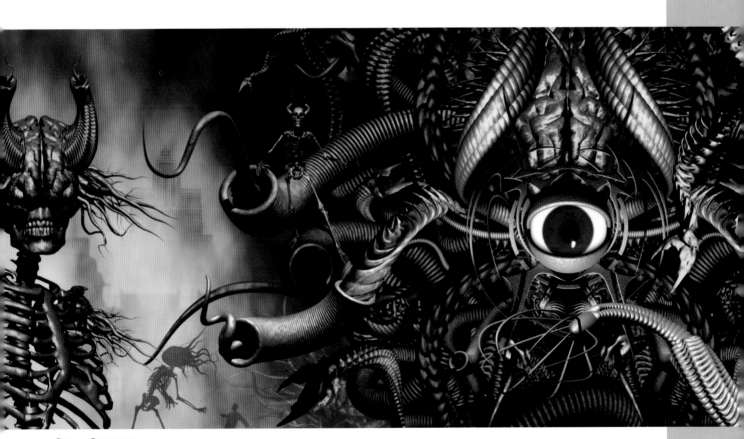

CYBER CTHULHU

SOFTWARE BRYCE, PHOTOSHOP, 3DS MAX ARTIST DAVE CARSON

ANCIENT EVIL

ART HAS ALWAYS REFLECTED OUR absorption with the inexplicable and the mysterious. Hand in hand with literature, and folklore and legends before that, it has illuminated our fascination and fear of the unknown.

Horror encompasses a huge variety of themes and content and can be found throughout the history of art and illustration; in the nightmarish altarpieces of Matthias Grunewald or Hieronymus Bosch, the gothic visions of Henry Fuseli, filtering through the intense and haunting Black Paintings of Francisco Goya, to the disturbing, abstract imagery of Francis Bacon.

The popular visual themes that we traditionally associate with the genre developed with the emergence of the Gothic novel in the eighteenth and

nineteenth centuries, with Horace Walpole's eerie novel *The Castle of Otranto* (1764) being the first to have an enormous impact. Above all else this was responsible for the term "Gothic" being associated with darkness and the supernatural, establishing the stereotypes of horror. Increasingly shocking terror tales appeared in the cheaply produced chapbooks of the late 1800s, which came to be known as "Shilling Shockers." These featured often gaudily colored sensational engravings. Later, magazines rejoiced in the name of "Penny Bloods" and "Penny Dreadfuls," and were luridly illustrated with woodcuts, taking the supernatural Gothic themes still further into the realms of demonology, occultism, and torture such as in the gruesome engravings of Mary Byfield.

The penny magazines produced a revolution in popular art throughout Europe and America, leading eventually to sensational Victorian periodicals. These featured classic ghost stories such as W.W. Jacobs' *The Monkey's Paw*, and were profusely illustrated with superbly macabre and melodramatic artwork by outstanding artists of the period such as Howard Pyle, Sidney Paget, and S.H. Sime.

Other important literary influences in horror illustration include the work of Edgar Allan Poe, his *Tales of Mystery and Imagination* being memorably illustrated by Harry Clarke. H.P. Lovecraft went beyond the Gothic to create a mythic cosmology, opening up the claustrophobic dimensions of the tomb to a supradimensional realm

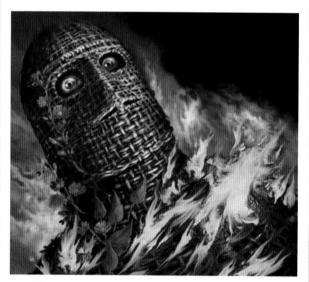

THE WICKER MAN

SOFTWARE **PHOTOSHOP** ARTIST **MEL GRANT**

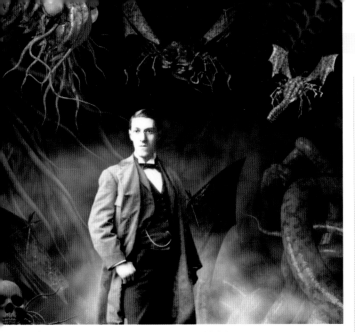

HOWARD PHILLIPS LOVECRAFT 1890–1937

SOFTWARE BRYCE, PHOTOSHOP, 3DS MAX ARTIST DAVE CARSON

of monstrous gods. During the pulp-era of the 1930s and '40s, which offered a panorama of pictorial thrills, Lovecraft's stories were illustrated by such genre masters as Virgil Finlay, Hannes Bok, and Lee Brown Coye. Lovecraft's "Cthulhu Mythos" stories have continually influenced artists through the decades, and remain an enduringly powerful inspiration.

The 1950s saw notorious comic-books mixing horror with pitch-black humor, including *Tales from the Crypt*, *The Vault of Horror* and later *Eerie*—titles which boasted the work of legendary artists such as Jack Davis, Joe Orlando, and Frank Frazetta. With similar dark humor, the controversial *Mars Attacks!* trading card series appeared in 1962, featuring artwork by Norman Saunders and Wally Wood, depicting scenes of horrible atrocities perpetrated by skull-faced Martian invaders.

Elements of the horror genre are recognizable within all sorts of wider fantasy settings; the frightening, malevolent forces of darkness found within a high

fantasy work such as Tolkien's *The Lord of the Rings* is one such example. Horror can effectively embrace and distort the conventions of science fiction, which, at its best, conveys a strong sense of dread in its exploration of the unknown.

A notable artist whose work links sci-fi with horror is H.R. Giger, his deeply erotic and often satanic paintings are at once magnificent and appalling; and his designs for the life-cycle of the *Alien* creature are distillations of a truly impressive collection of common phobias.

The horror art genre continues to evolve and develop, with modern media such as computer games flourishing under its ever-creeping shadow. Now, the advance of digital techniques means horror artists are wielding a fresh new array of implements with which to shock, provoke, disturb, and unsettle, as we'll explore in the following pages.

FROM HELL

SOFTWARE **PHOTOSHOP** ARTIST **DAVE CARSON**

MAKING MONSTERS
INSPIRATION, REFERENCE & ROUGHS

INSPIRATION FOR HORROR ARTWORK lurks everywhere: in the work of other artists, in literature, films and television, dreams, memories, and in all aspects of nature and the world around us. Much of my own work is still inspired by all the potent fantasy imagery I've remembered from childhood—the fantasy films and books that most fascinated and delighted me when I was a kid were the ones I found scary.

Raised on a diet of Universal and Hammer Horror movies, and later appreciating their German Expressionistic roots, I've tried to reproduce some of the mood of this imagery in my own work, replicating the use of dramatic light and shade. Thus my work often has a melodramatic feel, with liberal use of heavy shadow and under-lighting creeping in almost subconsciously.

If we maintain a curious eye, the range of influences that can affect our fantasy artwork never stops growing. Every movie we see, every novel or comic-book we read, every computer game we play, and every artist whose work excites us, is adding to our own individual visual database, so that each new discovery increases the store of ideas that will spark our imaginations.

THE FIRST STIRRINGS

Reference material can be extremely useful for providing information about an object, a figure, or a scene, filling the gaps in an artist's knowledge of construction, and helping to imagine how something might look from a particular angle or in certain lighting. To create convincing fantasy worlds an artist must often assume a variety of roles, including those of portrait painter and figurative artist, costume designer, special-effects designer, make-up and hair stylist, architect, industrial designer, set designer, and lighting director. Reference material helps in the creation of realistic elements that lend conviction to a fantasy scene, and with so many creative roles for the fantasy artist to pursue, it can offer very welcome support. Through the course of their work, most artists build up image archives that form an invaluable resource; filing potentially useful or inspiring images from magazine cuttings and online searches, compiling a library of picture books of all kinds, and swiftly capturing all kinds of original material using digital photography.

ROUGH CONCEPT FOR *FRANKENSTEIN'S LEGIONS*

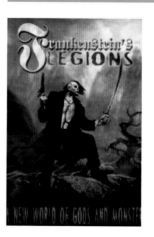

This quick cover mock-up is for a Gothic horror computer game concept. It includes a rough title design, and shows my first attempt at the idea for the game's fighting hero monster as a "hero of pain," wielding saber and flintlock. The intention was to give a sense of antiquity and decay, helping to convey the mood of the game.

A digital camera can be a very useful tool. If I want a particular texture, or need to see how something looks from a difficult angle, I can improvise the use of a household object for a prop, or ask a friend to strike a pose, and immediately photos are available as a welcome aid to drawing or painting. Working with models, along with costumes and props, can be great fun and very inspiring, and the process of trying out different poses and lighting leads to a great deal of creative possibilities.

LOOK AND FEEL

The first step in developing an idea will almost always involve initial roughs of some kind. This could be a good old-fashioned pencil sketch, a rapid digital rendering, or a rough-and-ready photomontage mock-up for color tests, compositional experiments, and so on. Usually, this is an essential part of the creative process, allowing the artist

to visually explore a number of ideas before deciding on the most effective approach. Roughs are a vital phase on any art job, and are necessary for communicating potential ideas to clients or colleagues. Rapid conceptual drawings also form the basis of any production-design process—the designs themselves may only be very rough sketches, but they perform an important role in conveying enormous amounts of valuable information in an extremely efficient form.

FILM CONCEPT IMAGES

The first image shows the model pose; the second, the grayscale work-in-progress sketch; and the third shows the rough conceptual image for the horror film *The Fly in Amber*. The sketches were produced quickly to help visualize characters and setting. The model, Christina, was used for this character throughout the series of illustrations, helping to maintain consistency and lending realism to the work. In this scene she watches as a little girl crumbles to ash.

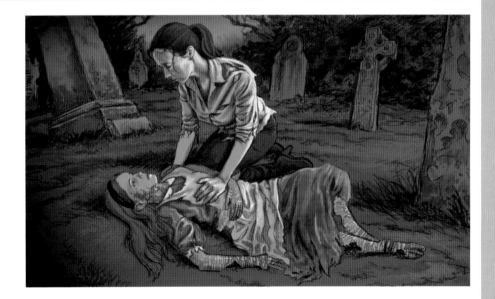

2D PAINTING & PHOTO MANIPULATION

A WIDE RANGE OF PAINTING TECHNIQUES, including those that closely follow traditional methods, can be applied very effectively with a graphics tablet and pressure-sensitive pen within paint programs like Photoshop® or Painter. The latter in particular, as the name implies, comes incredibly close to emulating the look, "feel," and behavior of real materials. An artist familiar with traditional techniques will find all the equipment they'd expect to find next to their drawing board or easel is available to use in virtual form, ready for use in "tradigital" artwork.

Photoshop offers three main painting tools: the Pencil, the Paintbrush, and the Airbrush. All apply the chosen foreground color to the image, and these digital tools behave just like their real-world counterparts in effect, producing a surprisingly wide range of expressive marks with the many different brush shapes available.

PAINTING A HORROR PORTRAIT

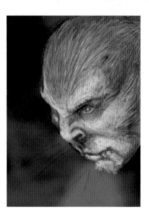 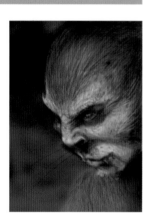 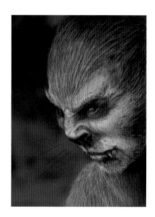 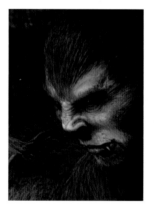

1 Digital painting techniques, as with their traditional equivalent, will greatly differ depending upon an individual artist's personal approach. This painting starts with a rough digital sketch.

2 The creature's shape is outlined, and loose details are quickly sketched using Photoshop's *Brush* and *Airbrush*. Some initial shading is added using the *Burn* tool.

3 Further detail is added, and the fur and facial structure of the beast is given additional depth and form by introducing some *Airbrushed* highlights.

4 The details are now tightened-up considerably. The *Airbrush* and *Smudge* tools are used to bring this monochrome stage to quite a finished level of detail.

5 The monochrome under-painting is finally colored with the tinting effect of semi-opaque *Brush* modes and *Layer Blending modes*. These modes are explained further in the Into the Hole tutorial (see page 62). The finished painting is a close-up portrait of a wolf-man, revealing the horror, remorse, and inner turmoil of the human spirit trapped within the beast.

TEARS OF THE BEAST

SOFTWARE PHOTOSHOP ARTIST MATTHEW BRADBURY

PHOTO MANIPULATION

Primarily a photo-editing program, Photoshop is ideally suited to the manipulation of photos in creating fantasy imagery, and when combined with its sophisticated paint tools, very advanced composites of photomontage and paint techniques can be achieved. When photo elements are distorted and worked over in combination with fully hand-painted areas, the striking effects obtained can be a lot of fun to play with, and ambitious subjects can be handled much more efficiently than if painted from scratch. This is particularly useful for fast concept work, where photo-manipulation is a great labor-saving approach in the pursuit of depicting heightened realism. Photoshop enables almost limitless variation, sometimes making it hard to commit to a final image.

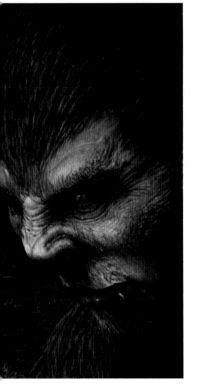

MOVIE CREATURE DESIGN

These photo-realistic creature tests have been painted within Photoshop, using heavily manipulated skin textures from digital photos to create composite portraits, merged together on an image of a suited actor. This level of realism is perfect for helping to design special-effects make-up for the movie industry.

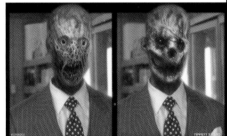

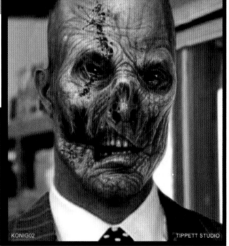

BALTHAZAR

SOFTWARE **PHOTOSHOP** ARTIST **PETER KONIG**

WORKING ON PHOTOS

By painting onto a scanned photograph with Photoshop's *Brush*, *Airbrush*, and *Smudge* tools, this little devil has been turned into a vicious imp creature.

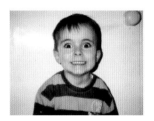

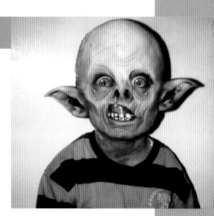

IMP

SOFTWARE **PHOTOSHOP** ARTIST **MARTIN MCKENNA**

NIGHTMARES IN BLACK & WHITE

I'VE ALWAYS ENJOYED CREATING both traditional and digital black-and-white imagery most. There's something especially pleasing about describing forms, particularly figures and portraits, using only line. Such drawings can appear simple, but it's often a challenge to attain the right level of detail using only hard-edged marks, and to achieve an effective level of contrast. My line work becomes quite intricate as I like to generate plenty of texture using hatching, cross-hatching and stippling. These are very traditional methods of generating tonal values in ink drawing, and can be achieved just as well using digital tools. By also applying white marks to black backgrounds, satisfyingly complex textures and detailing can be created akin to those achieved by traditional scraper-board methods.

DIGITAL DRAWING

Drawing with a graphics tablet—using the *Brushes* or *Pens* in Photoshop or Painter to make solid black marks—can come remarkably close to the experience of drawing with traditional pen and ink. The digital simulation offers a slightly less sensitive instrument, but it's not far removed from the feel of drawing with a technical pen such as a Rapidograph. When using any digital tool the tactile qualities of physical, real-world media might be missed, but, with the flexibility of working digitally, much greater freedom is available with the knowledge that there are no indelible ink marks.

This could be seen as either a positive or a negative development. The nervous energy of an expressive, scratchy, ink drawing could in theory be lost with the cleaner, more easily controllable digital approach. But when creating complex illustrations, the ability to adjust more than only small areas of line work, and to be able to limitlessly refine details to exactly your liking, is a joy. And that's without necessarily losing any of that vital spontaneity in the marks themselves that give a drawing life.

A rough pencil sketch was scanned and then adjusted using *Brightness/Contrast* to increase the line definition. Detail was added to the sketch with a fine *Airbrush*, using it like an ink pen to create a crisp black-and-white line drawing. A gray parchment texture was introduced behind the drawing, with the drawing layer set to *Multiply* so that only the black lines remained visible. Next, the highlights on the figure were picked out from the gray using the *Dodge* tool, to make it stand out from the background and give it a sense of being three-dimensional.

DISPROPORTIONS OF THE RESURRECTED FIGURE

SOFTWARE **PHOTOSHOP** ARTIST **MARTIN MCKENNA**

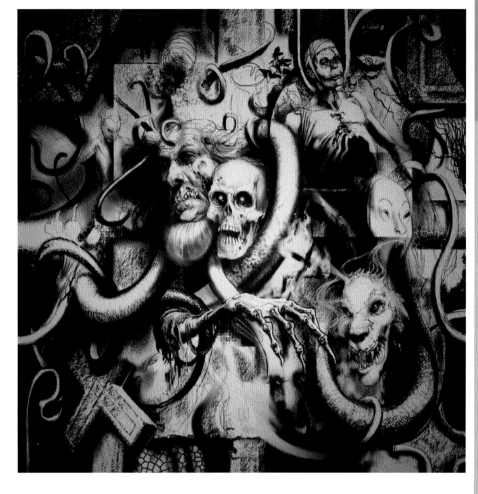

This image was done with a view to developing it into a repeatable pattern, usable as an endpaper in a book of horror stories. It employed considerable use of Painter's *Chalk* textures and *Pen* tool, using masks to constrain their spread a little.

MACABRE MONTAGE

SOFTWARE **PAINTER**
ARTIST **NICK HARRIS**

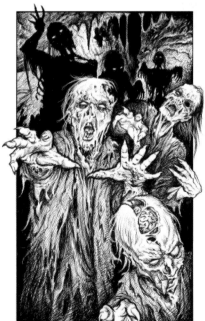

This was drawn entirely within Photoshop, without any scanned sketch. In addition to the black "ink" lines, I've used white to create highlights, and hatched and stippled over the black to create subtle blends that maintain the look of scratchy pen-and-ink drawing styles.

I've kept the foreground and background colors set to #0000 black and #FFFF white, and I switched between them as required.

ZOMBIES

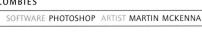
SOFTWARE **PHOTOSHOP** ARTIST **MARTIN MCKENNA**

3D SOFTWARE

INSTEAD OF APPLYING LINES AND COLOR DIRECTLY, as with the virtual *Brushes* and *Pens* in 2D paint packages, in 3D an artist is applying rules and properties within a modeling program. Rather than creating a surface impression of a three-dimensional scene, 3D software describes the scene in terms of geometry, lighting properties, surface properties, and camera angle.

3D graphics require the artist to "build" more than just what's visible, and so it's necessary to approach the work with that third dimension—the Z-axis—as integral to the thought process. While this is more complex than simply drawing an impression of a scene, the computer can very quickly manipulate a model to bring about radical alterations in the resulting 2D image.

Working in the third dimension has some tremendous advantages over 2D media, enabling artists to create extremely detailed, realistic characters, creatures, and environments, which can be reused and repositioned in an infinite number of ways. However, this is a very technical way of working. Much more than with a painting program, it takes time and a good understanding of the technology to produce work that bears an artist's stylistic identity, rather than the more anonymous default identity imposed by the software.

There are many 3D packages available to suit a wide range of uses. High-end 3D packages such as 3D Studio Max (3ds Max), Lightwave, Cinema 4D, and Maya are capable of incredibly lifelike results. Pixologic's ZBrush is an impressive simulation of sculpting in clay, something that is more intuitive and organic than other modeling programs.

Comparatively simple programs such as Bryce and Poser need less technical proficiency and are reasonably quick to learn. Bryce is a fractal landscape generator, and can help in fantasy painting by quickly creating dramatic skies and extremely convincing landscapes. Poser assists in creating basic human figures, which can be used as digital mannequins for figure reference and lighting decisions in test compositions. Poser figures may form the basis for fully finished characters, but they must be used imaginatively and worked on enough in post-production to avoid their generic Poser appearance.

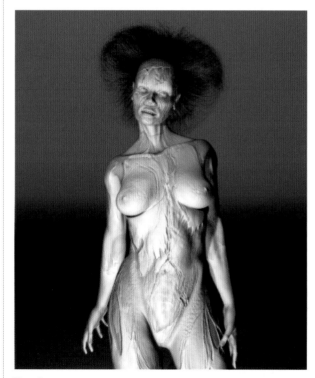

THE BRIDE

SOFTWARE **MAYA, DEEP PAINT** ARTIST **HOWARD SWINDELL**

TEXTURE SET-UP AND LIGHTING RENDER

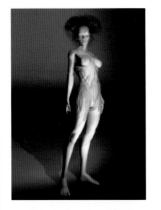

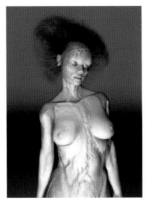

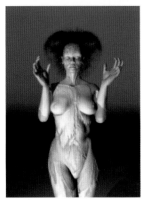

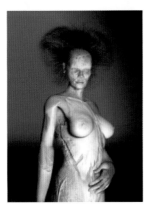

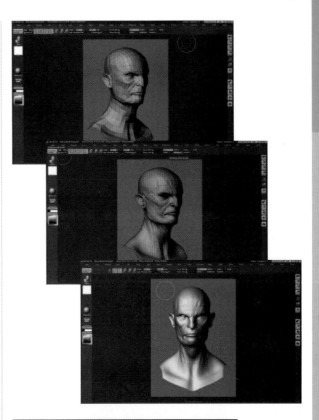

This female figure has been skilfully modeled from scratch. While this kind of figure work in 3D demands a high level of technical proficiency, the construction of hardware such as vehicles, machinery, and weaponry can be less difficult, as 3D modeling can create spectacular light reflections for glass, metals, and plastics with ease. Incorporating these objects into 2D compositions can produce highly effective results, combining 3D items with organic elements that might be more simply and expressively painted in 2D.

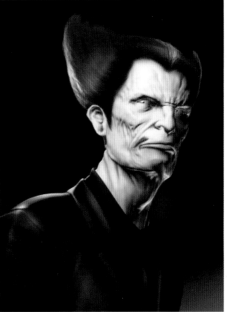

VAMPIRE

SOFTWARE MAYA, ZBRUSH, MENTAL RAY ARTIST HOWARD SWINDELL

SOMEONE OR SOME... THING

HERE ARE CHILLING FIGURES FROM THE DARKEST REACHES OF THE SUPERNATURAL, IMMORTAL CHARACTERS THAT HAVE STALKED THE SHADOWY HALLS OF HORROR THROUGHOUT ITS LONG HISTORY. BORN OF MYTHS AND LEGENDS, GOTHIC LITERATURE, CLASSIC HORROR MOVIES, AND COMICS, THESE MONSTROUS INDIVIDUALS HAVE BECOME ICONS OF FEAR. THIS SECTION SHOWS THE PORTRAYAL OF STRONG CHARACTERS IN HORROR ARTWORK, AND FOLLOWS THE CREATIVE PROCESSES RELATING TO HIGHLY EXPRESSIVE CHARACTER PORTRAIT PAINTING AND FIGURATIVE WORK.

TALISMAN OF DEATH

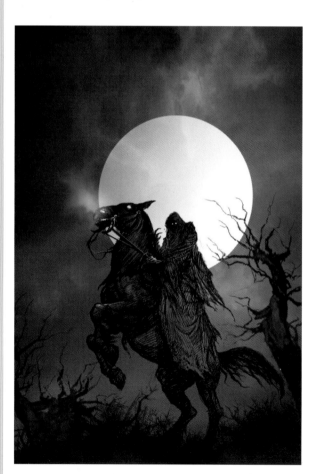

THIS IMAGE WAS CREATED for the cover of *Talisman of Death* by Jamie Thomson and Mark Smith, one of Steve Jackson and Ian Livingstone's series of *Fighting Fantasy* gamebooks published by the Wizard imprint of Icon Books. The original idea came from the text of the book, which describes a black horse and hooded rider: "A massive black stallion, its eyes pits of fire, snorting clouds of glowing cinders as it strains at the bit. Its rider, a dark spectral figure, is hunched and twisted." This cover required a very quick turnaround, so the pressure was on as I started work on the rough. What I had in mind was to show the horse rearing, almost in silhouette against a full moon, its rider a Death-like figure with points of light for eyes. Tim Burton's film *Sleepy Hollow*, and the Nazgul from *The Lord of the Rings* trilogy were the obvious references, but I hope I avoided producing anything too similar to either.

1 First I create a rough; sketching the main figure using two or three small sizes of *Brush*, and applying black as the foreground color. I really enjoy making rapid scribbles like this in Photoshop, where adjustments can be made easily, and quite finished-looking drawings can quickly develop. The basic hard-edged *Brush* doesn't make very expressive marks, but it's adequate for a rough sketch.

I've *Filled* the image with gray at about 75% *Opacity*, and used the *Eraser* and *Smudge* tool on the gray to indicate clouds. I've used the *Elliptical Marquee* to outline the shape of the moon, and *Filled* it with white. These main elements are all on separate layers, including the horse's breath and the small highlights that I've picked out in white.

Don't over work it
During the painting process, it's good to try and retain at least some of the sense of movement and spontaneity contained within an often rapid initial sketch. In places allow the underlying drawing to show through slightly, so as not to lose the original freshness of an image.

SOFTWARE **PHOTOSHOP** ARTIST **MARTIN MCKENNA** WEBSITE **WWW.MARTINMCKENNA.NET** EMAIL MARTIN@MARTINMCKENNA.NET

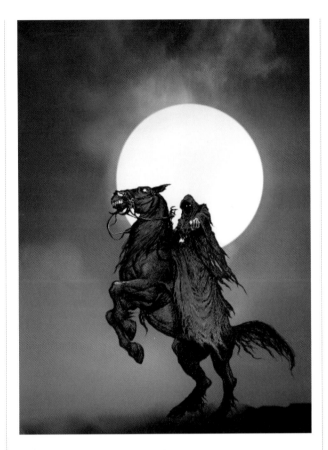

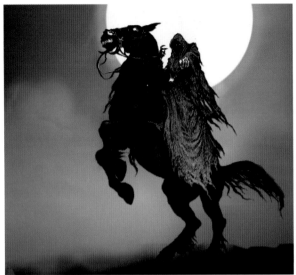

(2) The rough has been approved by the publisher, so now I need to quickly set about turning it into a more finished piece. The figure's pose and the general composition are okay, and should make for a reasonably bold image. I've allowed a little more canvas on the left because the image needs to bleed onto the spine of the book. At this point I've removed the tree and cloud layers as they were particularly rough; I'll paint new ones from scratch. I've kept the rough figure sketch and started to refine the drawing. I've changed the wraith's pose so that he's now pointing at the viewer, adding a bit more drama.

(3) I plan to use semi-opaque tones on the horse and rider, and later to apply transparent color that will subtly tint these gray shades. Here I've started to paint the horse in a darker tone, on a layer set to *Multiply* at about 70% *Opacity*.

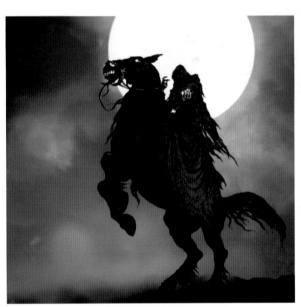

(4) Here I've shaded the rider with a slightly lighter monochrome tone. I've also re-introduced and re-worked the cloud layers that I'd removed earlier. I plan to give the image an overall color next and I want to see how this will affect the clouds.

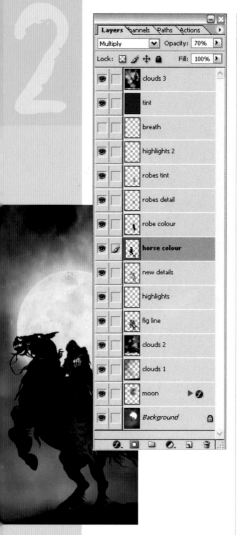

⑥ There's plenty of detail I could add to the horse, but I couldn't resist first adding in its fiery breath, and the burning pits of its eyes, nose, and mouth. On a new layer above the green tint layer, so that the warm colors would stand out fully against it, I applied very rough patches of red. I set this layer to *Color*, so that the red became transparent and blended with the white highlights on the drawing beneath. I then *Duplicated* the layer, and with *Hue/Saturation* I turned the red to yellow, the layers mixing like glazes to result in a blend of the transparent colors, while the real work of lighting the effects is done by the simple white highlights beneath.

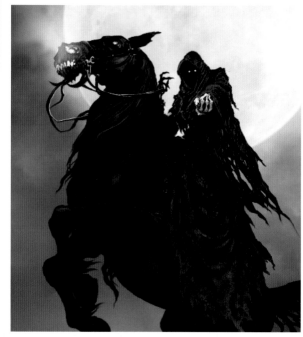

⑤ I've now done some more work on the clouds, adding further texture as well as darker areas. I've also painted the moon's surface on another separate layer behind the horse and rider, and given it an *Outer Glow* in *Layer Styles*. Using *Fill* on a new topmost layer, I covered the entire image with a green color, and set the layer to *Color* at about 60% *Opacity*. This has given everything a slightly gloomy green-blue tint.

⑦ I've adjusted the tint slightly, to make it more blue, and I've worked further detail into the wraith's tatty robes. My original grayscale drawing should convey enough of the basic detail of the ragged cloth folds—I liked the sense of movement it had in the spontaneous sketch, and I don't want it becoming too "finished"-looking. Just as well given the deadline.

⑧ I've painted in the first tree using *Gaussian Blur* to reduce some of its detail and to set it back behind the rider; this also helps to keep the horse and rider as the main focus. I put in a few more gnarled specimens to improve the composition. The stunted variety of horror tree is very useful for scenes like this, as they provide good spooky silhouettes without the intrusion of widespread branches. With the addition of a bit of low scrub, we start to get that haunted moor look, familiar from *The Hound of the Baskervilles* or *The Wolf Man*.

9 Final touches include the addition of some low trails of ground-mist; a final overall color adjustment to provide a slightly more pronounced palette of green and blue; and moving the fiery horse-breath to the topmost layer so that it appears more vibrant. This is the picture's only flash of warm color in a cool, muted, almost monochromatic scheme. It's been a necessarily simple, rapid process, and all I can hope now is that the publishers and authors all like it, and that the eventual book cover prints well.

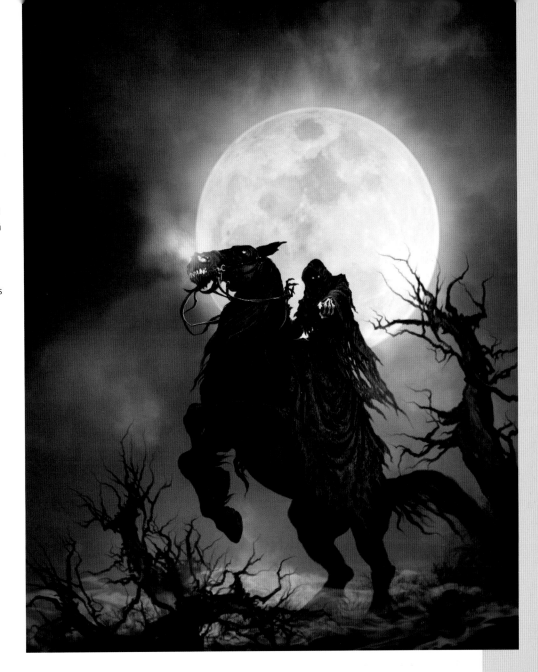

Giving your painting time and space

It's important to walk away from your image at regular intervals, so as not to become "blind" to it. Go and make a refreshing cup of tea; stare out the window at the world passing you by, and consider the fun you're missing out on because you spend far too much time indoors drawing monsters. This shift of focus gives you a much more objective eye when you return to the image, and you can consider it anew. "Live" with the piece for as long as possible before dispatching it to the client. I find it very easy to impetuously send off the image electronically during a final flurry of activity, only to look at it after a break and find things I wish I'd changed or fine-tuned.

PARTY GHOUL

MARK GIBBONS' ART CAREER BEGAN with Games Workshop, in what he fondly calls his "spiky period," in the early 1990s. He created artwork for almost every game and supplement GW produced, before the arrival of the Sony PlayStation® woke him up to a whole new world of possibilities. He freelanced for Eidos Interactive before joining Sony's Cambridge studio as a Concept Artist. Mark became the team's Lead Artist on the PlayStation 2 title *Primal*™. He is now freelance, dividing his time between illustration and creative consultancy.

"Most of my work involves conceptual or illustrative pieces and I rely on Photoshop to recreate the kind of art I used to make with paint and ink. The techniques I've employed to create *Party Ghoul* have been arrived at largely through trial and error, and it wouldn't surprise me in the least to be told there are far simpler ways of achieving the same end result. I think it's the speed and flexibility of digital media that I value the most. With the freedom to work on separate layers, the software encourages a wild experimentation that would require a cast-iron nerve to attempt on canvas."

Horror is sexy
Even a rotting, brain-drinking zombie girl like this can appear glamorous and strangely seductive, drawing a fine line between repulsion and attraction. Horror and sex are often closely linked and can be used to great effect when combined, stirring in the viewer a conflicting mix of responses.

(1) I almost always begin with a pencil drawing. This particular rough sketch is actually a better drawing than the scanned, "cleaner" version I'll use as the basis for painting. I'm not particularly concerned about this since I suspect the actual pencil lines will barely feature in the finished art—I'll merely be using them as guidelines. That's not always the case however. In some of my pieces, scratchy, scribbled pencil marks add vital texture to the image and I work to maintain their presence. Since Party Ghoul is shaping up to be more of a "glamour" shot, I'll probably paint over or erase most of the pencil lines as I go.

I scan my pencil drawing into Photoshop as a grayscale image at 300dpi. *Image > Adjust > **Auto Levels*** increases contrast and brightness in the drawing. Sometimes I'll also adjust the *Brightness/Contrast* if I feel the pencil work needs more punch.

I convert the grayscale image to RGB via the *Image > **Mode*** menu, then copy the background layer and set its *Blending mode* to *Multiply* with an 85% *Opacity*, just enough to take the hardness out of the black lines and help them sit better with all the digital painting that's about to come.

I then *Fill* the original background layer with white so I've a fresh canvas to work on.

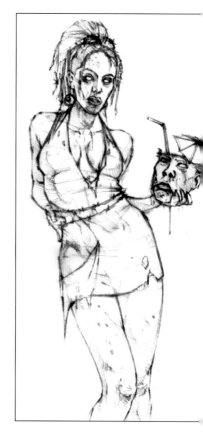

I recommend naming all your layers as you create them. Things can get very confusing otherwise and you're likely to waste hours clicking between them trying to remember what's painted where.

The freshly created *Multiply* layer is my "Blackline" and it's my template layer that will steer the entire painting. Setting this layer to *Multiply* ensures that the pencil drawing will remain my visible guide throughout.

SOFTWARE **PHOTOSHOP** ARTIST **MARK GIBBONS** WEBSITE **WWW.REDKNUCKLE.COM** EMAIL **MDGIBBONS@BTINTERNET.COM**

2. Now I start adding some color. I create a new layer below Blackline, then usually at random, I pick a foreground and background color and apply a *Render > Clouds* filter. By default these clouds look very busy so I *Edit > Transform* them, scaling their layer up until I've created a vague, smoky backdrop. I'm not worried about the actual colors in this layer right now since they'll change dramatically in the next stage. I name this layer "Clouds." I *Crop* the image after so much *Transforming*, otherwise the file size will grow too large.

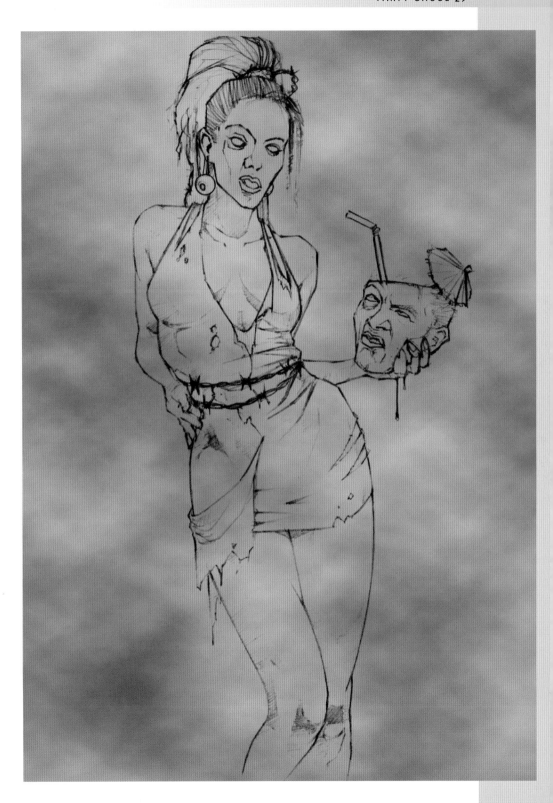

4 I now want to lift the Ghoul herself away from the backdrop. I create a new layer and paint the lady and her "drink" in a flat color. Generally I'll pick a fairly neutral midtone from the wealth of colors now present in the backdrop. As I said earlier, these backdrop layers are now my source palette. I never, ever use *Swatches*.

I set the *Blending mode* to *Overlay* so all that backdrop texture shows through before *Ctrl + clicking* in the *Layers* title bar to select everything I've just painted. Picking appropriate foreground and background colors, I apply a *Gradient* to the Ghoul. The basic idea is that the character gets darker from top to bottom as the primary light source is the one in the top right. I name this layer "Gradient."

So, what I've now got is a rich, textured backdrop and a character silhouette in complementary tones, ready for some proper painting to begin.

I now need to add a number of painting layers above the Gradient layer to work in:

• "Flat Color"—*Normal Blending mode*. Used as you might expect for painting on basic colors.

• "Shadows"—*Multiply Blend mode*. Sits above Flat Color in the layers palette and will be the layer where most of the shadows will be applied.

• "Highlights"—*Screen Blending mode*. Sits above Shadows in the layers palette and it's where I'll paint my highlights.

• "Detail"—*Normal Blending mode*. Sits above Blackline in the layers palette. This is the layer where much of the fine detail will be painted. It's also the layer that will obscure much of the pencil work that's in the Blackline layer.

• "Glaze"—*Hard Light Blending mode*. Sits above all the other layers. It's the layer that I use to paint on washes of color to add either richness or variety of tone or, in contrast, to pull areas of conflicting colors together.

Most of the actual painting work I do in Photoshop begins and ends with the *Brush* tool set to *Airbrush* at *Normal* blend mode with 50% *Flow*. I find that with a variety of different sizes, angles, and hardness settings the *Brush* best recreates my "real world" paintbrush.

3 This is one of the most important stages since, in addition to getting a decent backdrop laid down, I'm also establishing the basic palette of colors I'll use throughout the painting process.

The first thing I do is drag some convincing textures into the scene. I've a library of photographic references that I use for this. I found a great photograph of a corroded metal sheet that I use in many of my paintings merely to add a degree of "noise" to my digital work. In this instance, my new "Metal" layer sits above Clouds and its *Blending mode* is set to *Overlay*.

I'll play around a little with *Image > Adjust > Color Balance* and *Hue/Saturation* to try to establish a basic palette and ensure that the

Metal and Clouds layers are working well together.

Now I duplicate the Metal layer a couple of times and experiment with *Bending modes* and *Gradient* masks. The two duplicate Metal layers are both set to *Screen Blending mode* and these will act as my lights for the scene. I tweak the *Hue/Saturation* and *Color Balance* settings to get a cool blue light coming from the top right of the scene and a hot pink from the bottom left.

Gradient masks on each layer allow me to adjust the "fade-off" for these light sources. Once I'm happy with the general effect, I want more detail in the backdrop so I drag in a second photographic reference: it's a cracked concrete wall, to add detail to the lower portion of the painting.

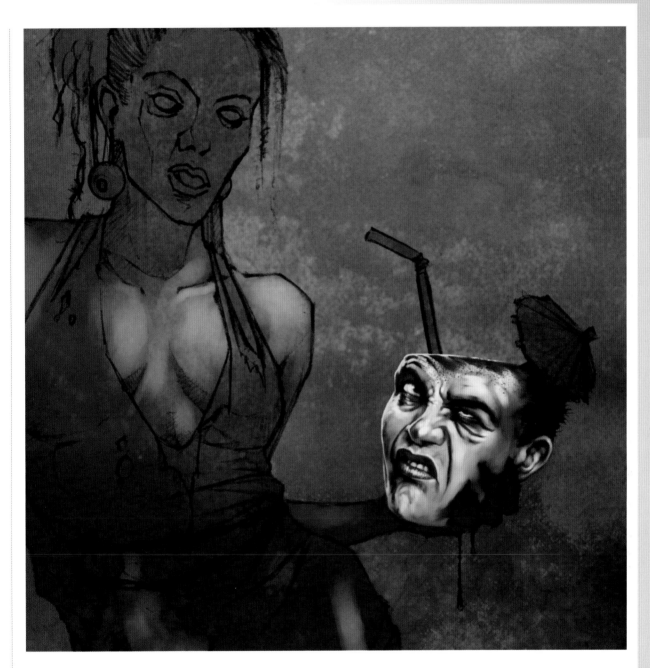

⑤ I start by painting in some quick shapes on the Shadows and Highlights layers just to get a rough idea of how the light should fall across the figure, but I get bored of this very quickly. I'd rather get a small snapshot of the final illustration complete, to hopefully confirm I'm heading in the right direction. I'm not entirely sure this is the wisest move, but for me I'd like some reassurance that things will come together nicely.

I decide to complete the Ghoul's "drink." It's a severed head and they're always fun to paint! This is useful too since it allows me to establish tonal values and an "on canvas" palette of colors.

I utilize all those painting layers I created in step 4 to complete the unfortunate head and I'm now satisfied that the piece is going to work.

2

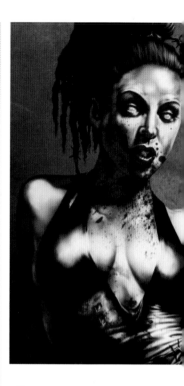

⑥ I'm focusing here on a specific area of the Ghoul in order to show the process I'm applying to the rest of her more clearly. I begin by painting her legs using the same methods and layers as I did with the severed head: selecting colors from the scene with the *Eyedropper* tool and laying in tones. At the end of this stage I'm happy with the color and shape but her limbs are looking a little too healthy.

I decide to reuse my old friend the Metal layer and duplicate it once more, dragging it up the layers palette until it sits above Backlight. I keep the blend mode on *Overlay* and suddenly the Ghoul's legs take on a rather unhealthy mottled tone—looking better.

Finally I trawl through my reference archives and find a selection of blood splatters I created previously when throwing red ink around on a sheet of card. I drag a number of these into my painting, and set their blend modes to *Multiply*. They need a little tweaking to get them to sit right against the Ghoul's skin. The blood's too crisp to start with, so a little *Gaussian Blur* helps. The red's a bit too vivid, so I tweak the *Hue/Saturation*. Lastly, I use the *Dodge* and *Burn* tools to add shadow and highlight so the blood follows the contours of her skin. I like it. She's beginning to look suitably ghoulish.

Now it's a question of applying these elements to the rest of the figure.

⑦ By this stage most of the painting work is complete. After focusing my attentions on Party Ghoul's legs, I work the rest of her up in the same way. Special attention is given to her face, in particular her dead eyes and the placement of the blood spatters around her mouth. She's clearly a sloppy drunk. I've added a little extra detail to the background; picking out highlights in the concrete, and laying in a soft shadow from the Ghoul. It's fairly subtle, but helps to make the wall look more convincing. At this point I also crisp up some of the layers. Sometimes the *Airbrush* tool can leave painted areas looking a little "soft." By using *Filter > Sharpen* or **Sharpen More** (plus **Fade Sharpen**) I can tweak these areas to my liking.

⑧ Whenever possible, I like to leave 24 hours between completing the painting and actually calling it "finished." I find a day away from the piece allows me to summon up a little objectivity so that when I look at it again, it's with fresher eyes and any problems with the illustration are more likely to pop out at me. In Party Ghoul's case, I found myself wanting to pump up the color somewhat as it all felt rather subdued. I added a top layer, called it "Gel" and set the blend mode to *Overlay*. This creates the equivalent of a colored gel over the entire painting, which will pull the tones together. I filled the layer with a cool blue but as I wanted to keep this effect subtle, I dropped the layer's *Opacity* right down, to 20% in this case. Finally, I made a number of small tweaks to *Color Balance* and *Hue/Saturation* on some of the layers (as I've been doing throughout) and I'm done. Nothing left to do now but add my monogram.

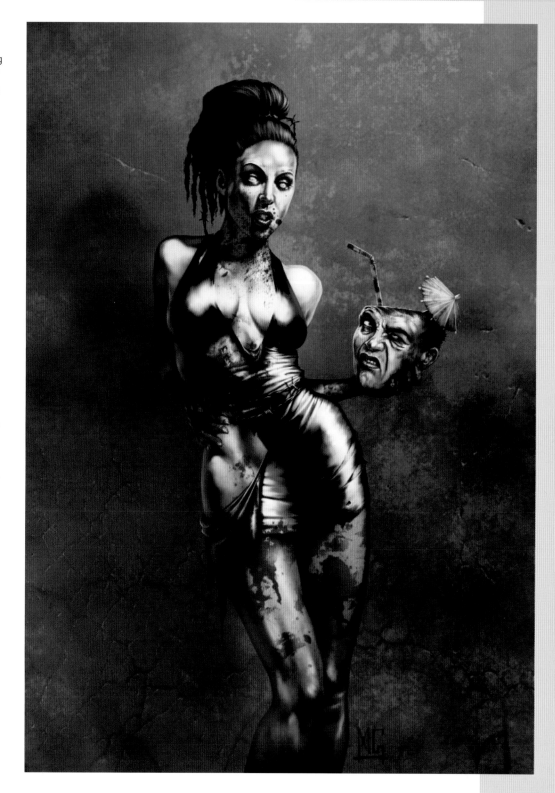

TUNNEL ZOMBIE

Felipe Machado Franco is an illustrator and designer based in Bogotá, Colombia. He has worked extensively in the field of heavy-metal album covers, designing sleeves for Angelus Apatrida, Spit Fire, Freezing Darkness, Toxic, and his own band *Thunderblast*. Since 2003 he has worked for Lucas Licensing, producing promotional posters and artwork for films such as *Star Wars Episode III*. Felipe also teaches Digital illustration at the Pontificia Javeriana university in Colombia, and has a book of his illustration due for publication soon.

Felipe's tutorial demonstrates the use of some of Photoshop's fundamental photo-manipulation tools, using simple editing techniques to combine photo elements in the creation of a zombie character and his underground lair.

"The technique I use is what I call Digital Photo-Composed Illustration. The very first step in my process is to source a selection of photos which I'll integrate into my composition, or if I have nothing suitable on file I'll take new digital photos of objects, textures, or, as with *The Tunnel Zombie*, a model suitably attired and lit."

Opacity effects and choosing a palette
For photo-manipulation I like using Layer Opacity, *allowing textures to blend and merge together to create cool and surprising effects. I also like choosing a strong but carefully limited palette, like the cyan and blue hues of* The Tunnel Zombie.

Brightness/Contrast

Brightness: -4

Contrast: +10

OK
Cancel
☑ Preview

1 I start with the photo I'm going to use for the background of the illustration. In this case it's an atmospheric shot of a tunnel in an old Spanish fortress. The photo has some natural blue tones that I like, so I give them extra *Saturation* and *Contrast.*

SOFTWARE PHOTOSHOP ARTIST FELIPE MACHADO FRANCO
WEBSITE HTTP://FINALFRONTIER.THUNDERBLAST.NET
EMAIL NEWDIMENSIONART@YAHOO.COM

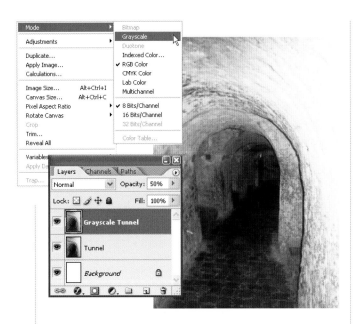

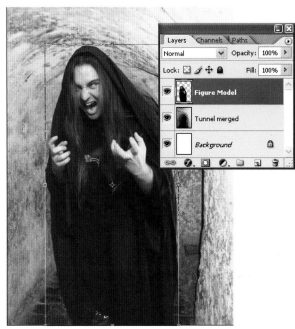

(2) I make a copy of the tunnel photo and change the *Image Mode* to *Grayscale* in the new file. I then drag the grayscale copy of the photo into the first (master) file. I position the new grayscale photo on top of the original color image, giving it 50% *Opacity* in the *Layer Style*. This helps create the paler palette I want for the illustration.

(4) After I have my character neatly cut out, I start to roughly *Transform* the figure to re-size it, I then move it around to see how I might compose it within the background.

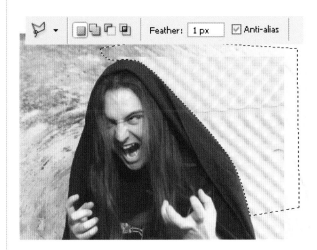

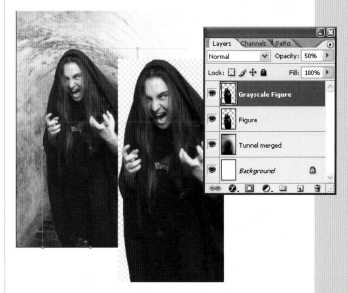

(3) Now I drag in the photo of the model I'll use for my character—my friend Oz helpfully posed as the Zombie. The first thing is to use the *Polygonal Lasso* tool, with a *Feather* setting of 1 pixel, to select areas containing extraneous material that I don't need, so I can then *Erase* them.

(5) Next I repeat exactly the same *Grayscale* process as in step 3, this time for the figure, using *Rulers* guides to be sure the color image and the grayscale image line up exactly.

6 Now comes the fun part—turning your friend into a monster! I choose a nice photo that I took of a human skull in an art class and I position the photo as a new layer on my master file. I *Transform* the photo to be sure that the size and angle are accurately scaled to the model's face. For this I work with a layer set temporarily at 50% *Opacity*, so that the transparency of the image helps me to accurately locate things, like the skull, over elements on the layers beneath.

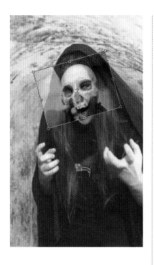

8 At this point I introduce facial shadows using the *Airbrush* on the model layer underneath the skull, and I make sure the hole of the nose is dark enough. Using the *Lasso* tool, I create a mask around the character's eyes and *Fill* the selections with white. Whitened eyeballs will always look scary.

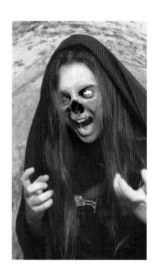

7 I zoom into the illustration and start *Erasing* all the material from the skull that I don't need. I *Erase* the skull sockets to allow the eyes of the model to show through, and the resulting mixture of the two photos starts to create a new creepy face.

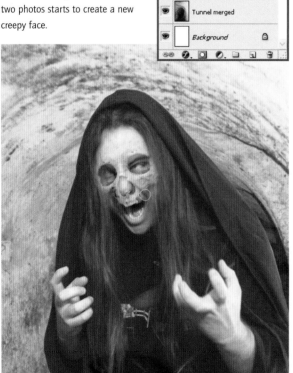

9 I now drag a photo of some interesting wall texture into my master file. I usually work with grayscale photos of textures because it helps me to unify different color tones later. Making sure that every part of the area where I want to add texture is covered by my wall photo, I *Rotate* it to cover the face; and then I use the *Clone* tool, "rubber-stamping" the texture onto all the flesh areas of the figure.

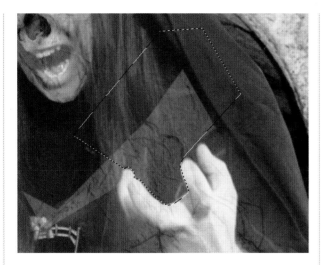

12 At this point I increase the levels of *Brightness* and *Contrast*. It's necessary to regain some of the shadows lost due to adding the layers of semi-transparent texture, so I use the *Burn* tool to darken things up and add contrast around the nose and mouth, under the chin and around the hands, as corpses tend to develop dark fingers and feet as they decompose.

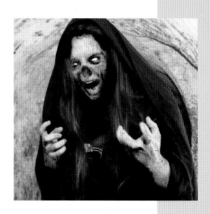

10 Now I reduce the texture layer to 20% *Opacity* to make it slightly transparent. The *Opacity* percentage makes a big difference to the effect I want to achieve. I then *Erase* all the areas of texture that I don't need, and now you can see that the character has gained a slack, corpse-like skin.

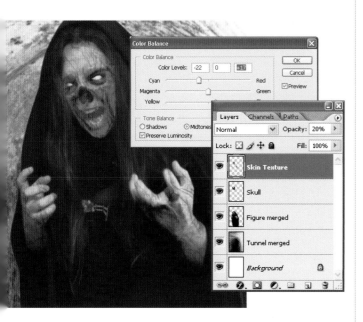

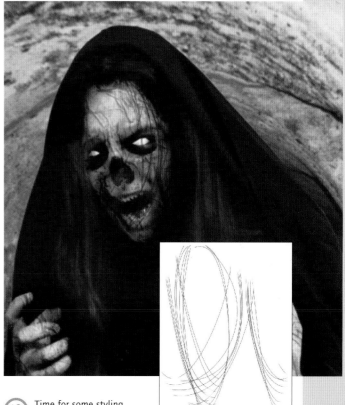

11 I use *Color Balance* next to give the texture layer more cyan and blue tones, initially in *Midtones*. I then do the same with *Shadows* and *Highlights* until the texture layer gives a nice blue tone to the skin. Finally I *Merge* the texture layer, which I've set at 30% *Opacity*, onto the character's layer.

13 Time for some styling details now, and I want to add more straggly hair. In a new canvas I draw a nice curved line to represent one hair, and then I copy the layer repeatedly to create many hairs. Each one is then *Transformed* to look slightly different. Once I have enough hairs I *Merge* all the hairs onto one layer and *Duplicate* that layer to create even more. I merge these layers into one and then drag the hair over and into position.

14 I give this "Hair" layer a small *Motion Blur* effect, so it blends to appear naturally part of the figure.

Turning my attention to the background again, I think the tunnel is too bright, so I create a new black-filled layer beneath the cave photo. I give the cave photo layer a 50% *Opacity*, allowing the underlying "Black Fill" layer to make the tunnel look darker and more ghostly. To enhance this feeling I add extra irregular areas of black to the tunnelwalls, varying the *Opacity*. Once done, I merge the two layers into one.

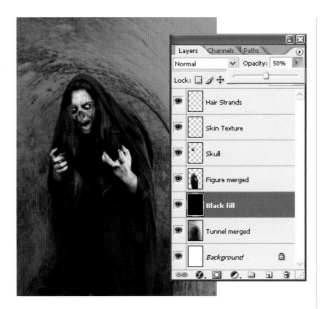

15 The next step is to add some fog. The best and fastest way to simulate fog is by using a photo of fire. I choose a good flame-filled photo from my personal archive, and convert it into a grayscale image. Then I place it as a new layer in my master file. I give this fire some cyan and blue hues using *Color Balance* mostly in the *Shadows Tone Balance*.

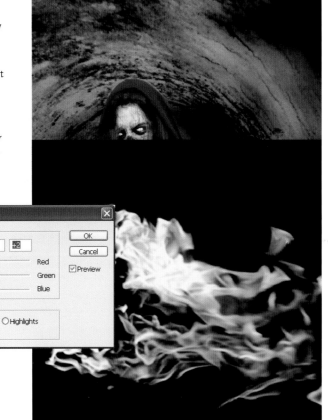

16 *Erasing* all the surrounding material that I don't need from my "Fire" layer, I then set that layer to 50% *Opacity*.

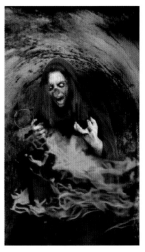

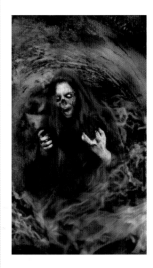

17 Now I *Duplicate* the Fire layer as many times as I need. I place some of these new layers beneath the "character" layer (so it appears as if the fog extends behind him) and some on top, *Transformed* into different positions and set to various *Opacities*.

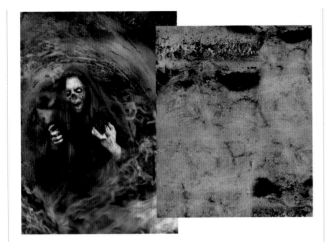

18 Using the *Eraser* I tidy up my layers of "Fog," removing any untidy shapes that I don't like.

I want to add more texture. From my stock photos I choose another wall texture, this time to use selectively over the entire illustration. Placing the new texture above all the layers of my master file, I give it a 30% *Opacity*. I make sure that the new texture has enough of a blue hue, as this gives the illustration a rougher, more raw look overall.

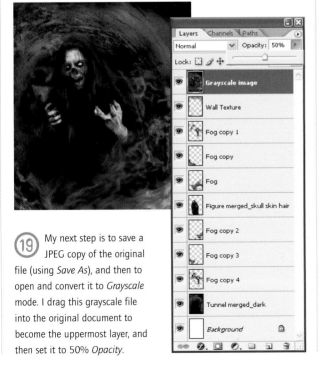

19 My next step is to save a JPEG copy of the original file (using *Save As*), and then to open and convert it to *Grayscale* mode. I drag this grayscale file into the original document to become the uppermost layer, and then set it to 50% *Opacity*.

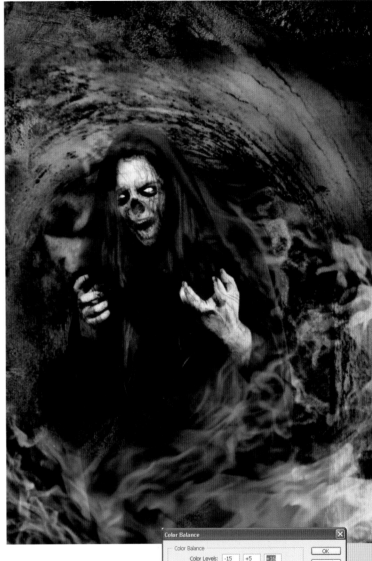

20 Using *Color Balance* I adjust the tones of the new grayscale layer by adding more cyan and blue. The final step is to *Flatten* the image, and then make some last-minute adjustments using *Color Balance* and *Brightness/Contrast*.

RENDING GAS

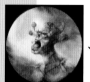

JIM **P**AVELEC **IS AN ILLUSTRATOR** based in Illinois. In 1974, after viewing *The Exorcist* at the tender age of two, a pattern began to evolve in young Jim's life, one that he would cultivate to this very day—a passion for imagery most foul. Demons, monsters, and devils of all kinds consumed his every waking hour, and he found the best way to express his love was with paper and pencil, a little paint, a Wacom tablet, and computer monitor. Jim's fantasy and horror illustration has been much in demand from games companies such as Wizards of the Coast, White Wolf, AEG, and magazines such as *Heavy Metal*.

In this Photoshop tutorial, Jim describes how he uses digital manipulation and painting techniques that are combined directly with background textures and preparatory work created using traditional watercolor and acrylic media.

"When I first began to see digital illustrations I was unimpressed with a majority of the work. The images were plagued by a lack of texture, a heavy-handed reliance on photographic reference, a disregard for edge variation, and an absence of personal style. These things made me hesitant to set foot in the digital world. Also, I felt that going digital would cause me to lose touch with the traditions and techniques of great painters from the past like Rembrandt, Velazquez, Waterhouse, Eakins, and N.C. Wyeth. But when I began to see the work of illustrators like Justin Sweet, Ashley Wood, Matt Stawicki, and Todd Lockwood, my attitude began to change. I started to believe that perhaps I could keep in touch with tradition, and even learn a thing or two, by trying this new medium. Now, a few years later, about half of all my finished illustrations are produced digitally.

"The piece I'm explaining was commissioned by Hidden City Games for their *Clout Fantasy* chip game. A chip poses an interesting set of problems because the finished piece is set into a circular format, and is reduced to a very small size for reproduction."

(1) My first task is to complete a finished sketch. I mostly work with graphite and charcoal on paper, then I scan the artwork into Photoshop.

A circular challenge

This piece was commissioned by Hidden City Games for their Clout Fantasy *chip game. A game chip (a lot like a poker chip) poses an interesting set of problems for the illustrator because finished artwork is set into a circular format, and is reduced to a very small size for reproduction. It was a challenge to convey all the horrible effects of this cloud of deadly gas, as it rends the body of this stitched-together Frankenstein corpse, violently tearing it apart.*

SOFTWARE **PHOTOSHOP** ARTIST **JIM PAVELEC** WEBSITE **WWW.JIMPAVELEC.COM** EMAIL **GENETHOQ@COMCAST.NET**

masonite using Liquitex gloss medium. Depending on what kind of textures I want to achieve in the piece, I add different kinds of medium to parts of the image, maybe some heavy gel medium, or some of the same gloss medium that I used to stick the paper to the board. I then apply water-based dyes (acrylic and watercolor) to the paper using a dropper and I also spray them judiciously with a water mister. The colors flow and blend in an organic way—it's very pleasing to the eye. I may also use a sable brush and paper towels to manipulate the pigments further. The important thing at this stage is to just play around and not be overly concerned with details.

Because the dyes are water-based they dry quickly. Finally, I put the finished product on the scanner and import it into Photoshop at 100%, 300dpi.

④ Now I can concentrate on the figure. I begin with some broad textural and tonal work. I strive to establish interestingly organic textures for the skin, and I keep files of textures on hand for quick access. These files are all derived from photos I have taken with my digital camera—mostly close-ups of tree trunks or roots, moss-covered rocks, rusty metal, even different types of animal skins from various zoo trips. I take the texture image, *Copy* it, and *Paste* it over the figure. On the layers palette I then go through the different types of layer modes and *Opacities* to get the look I want. Again, it's an amazing convenience to be able to scroll through options to achieve a desired effect.

② My next step may seem a bit strange in a demonstration of working digitally, but I think this technique really adds to the overall mood of the final image. I print out my sketch onto 80lb Strathmore drawing paper. I spray-fix it, and I mount it onto a piece of

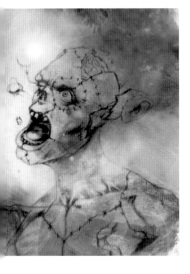

③ Next I apply a *Threshold* adjustment to my initial sketch, in order to bring up the

main lines. I then click on one of the dark lines using the *Magic Wand* selection tool with the *Tolerance* set very high and the *Contiguous* box unchecked. This allows almost all the sketch to be selected without any of the white background. I copy this and paste it onto the painted background. Now it's playtime. Using the *Hue* and *Saturation* sliders and various other tools, including the *Rubber Stamp*, *Smudge*, and *Paintbrush*, I begin to manipulate the background. *Copy* and *Pasting*, *Blurring*, and even using a *Lens Flare* effect may all be used to get the background to a point where I'm happy with it, bar the finishing touches.

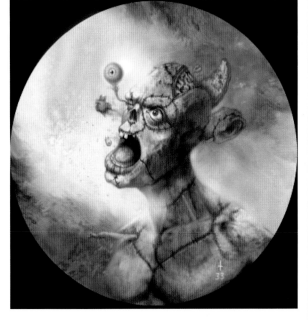

⑤ At this point I use some of my favorite *Paintbrushes* and I work up the details of the figure, always trying to keep my edges in mind. A few more tonal adjustments and some rendering of detail, and this monster is very nearly done. I play around with some areas where the background and foreground meet, include my signature, and frame it up for my client; then it's on to the next project—and fast, too, because the deadlines loom like... well, like a gas that would cause a stitched-up corpse's anatomy to pull apart!

ARNOLD

NICK HARRIS HAS PRODUCED ARTWORK for clients including Oxford University Press, Puffin Books, and Doubleday; illustrating such classics as *The Wind in the Willows* and *The Picture of Dorian Gray*. He has also worked in animation with Richard Williams on projects including *Who Framed Roger Rabbit?* For most of his career Nick has worked traditionally, mostly in line and wash, until he moved into the digital realm in 2000. "I'm a slow learner and don't make half the use of the machine's power and capabilities that I should. I use it as a glorified no-mess art box, using drawing and painting methods that are as close as possible to those I'm used to in the real world. Painter and a large Wacom graphics tablet are my most favored tools."

Using Painter for most stages of this comical depiction of a corpse waking from the dead, Nick employs layer blend modes, a *Tinting Brush*, *Chalks*, *Oil Pastels*, and *Round Point Pen Brushes*, as well as *Paper Texture*, in painting techniques that adhere as closely as possible to the processes he would use with traditional media. As Nick says, "Arnold found that a strong cup of coffee, first thing in the morning, allowed him to think right outside the box."

(1) I started by sketching in Sketchbook Pro at 72dpi. Of all the art software I use, the *Pencil* tool in Sketchbook Pro is the nicest for drawing. I tend to go for a dark umber color to draw with as I find it less harsh than pure black. The minimum-maximum range is set fairly narrow using *Custom Brush Settings* at about 2–8 pixels. I then blocked-in some tonal values using a couple of custom-sized *Airbrush* tools. I can't emphasize enough the importance of a good underlying drawing. It allows you to get away with so much more in your painting. There is almost no substitute for a good drawing.

SOFTWARE **SKETCHBOOK PRO, PHOTOSHOP, PAINTER** ARTIST **NICK HARRIS** EMAIL (VIRGIL POMFRET ARTISTS AGENCY) VIRGIL.POMFRET@ONLINE.FR

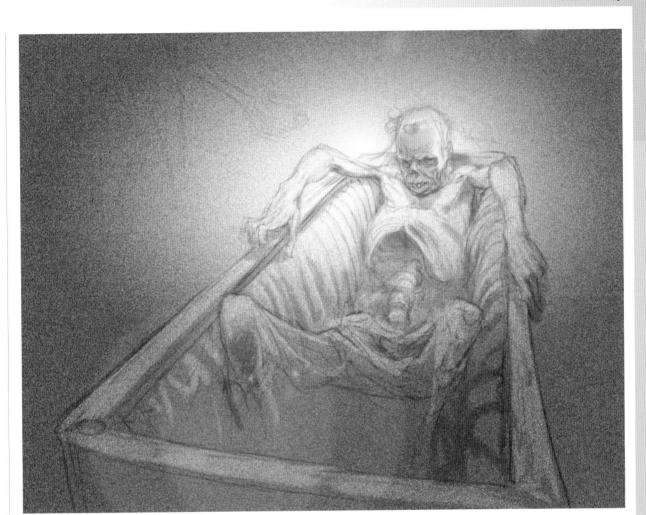

2 I increased the *Image Size* by raising the dpi to 300 in Photoshop, making it possible to add more detail. I removed the glaring white background by introducing a *Radial Gradient Fill* layer beneath the drawing. I copied this from the background to a new layer and set it to *Linear Burn*, although *Multiply* will have a similar effect. I dragged its center to highlight the head and shoulders of Arnold. At this stage it was too clean-looking, so I duplicated it and introduced some *Noise*, and then reset the *Threshold* to lose some of it and changed the blend mode to *Multiply*. I played with the two *Gradient* layers' transparency to restore tonal value so it wasn't too dark, and then applied two *Spotlight Filter Effects* either side of Arnold's head to pick him out more, before saving this stage as a PSD.

Influences from vintage horror cinema
You can control the whole mood of an image with perspective and lighting. They may seem clichéd to some degree now, but look at the work of German Expressionist filmmakers of the 1920s and '30s such as F.W. Murnau's Nosferatu, eine Symphonie des Grauens. There's a lot to learn from them.

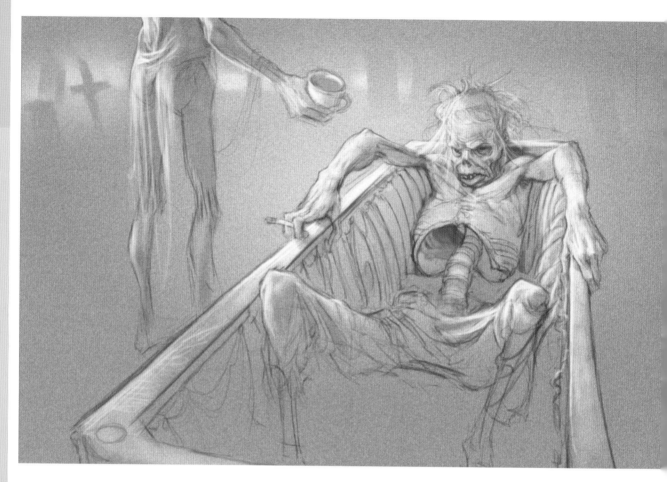

③ The next stage was to move into Painter, my favorite software to work in for painting and drawing generally. I added a layer which I set to *Multiply* rather than the normal *Gel* (often used because it's compatible with Photoshop, which also uses this *Blending mode*), and here I added dark tones using the basic round *Tinting Brush*. I added another layer where I painted on light tones using *Chalks*, *Oil Pastels*, and *Round Point Pen* variant *Brushes*. You can play with *Paper Textures* and their relevant controls as the mood takes you. I worked on the drawing layer using the *Round Point Pen* variant, at about *Size* 3 and at 40% *Transparency*. If you get the tonal values correct, you can paint a picture in any colors you like, and it'll still work.

A digital transition

"Once I got past the terror and total ignorance stage and got hold of some professional-level painting software, the computer was a revelation. There is so much potential in those little boxes of tricks it's sometimes counterproductive, offering too many choices for someone as indecisive as me! Digital painting is clean and flexible. You can mix media (watercolor and oil paint, for example) on the same canvas, in a way that's impossible in the real world. You can create masks to apply whenever you need them, and once a mask is made it's made—in the real world you'd have to make a new one each time. You can isolate elements onto different layers to work on, which means that using those layers, you can move, scale, and duplicate elements at will. You can save different stages of a piece to go back to and take in different directions, which means that if you develop good working practices you can undo the majority of your mistakes. And making and sending copies, and storage, has never been easier."

4 I continued to work up the drawing in this way at length. I added another *Gradient* layer in Photoshop, set to *Overlay*, reduced its transparency and picked out some of the shadows on a layer mask, using a textural *Brush*. I find that masks are much more stable in Photoshop than in Painter. In fact most processes are, but Painter is nicer to paint in if you are more familiar with traditional media, because it emulates the experience better.

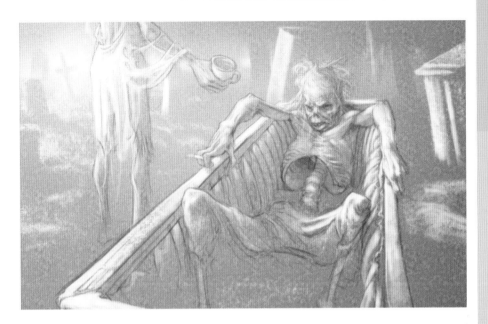

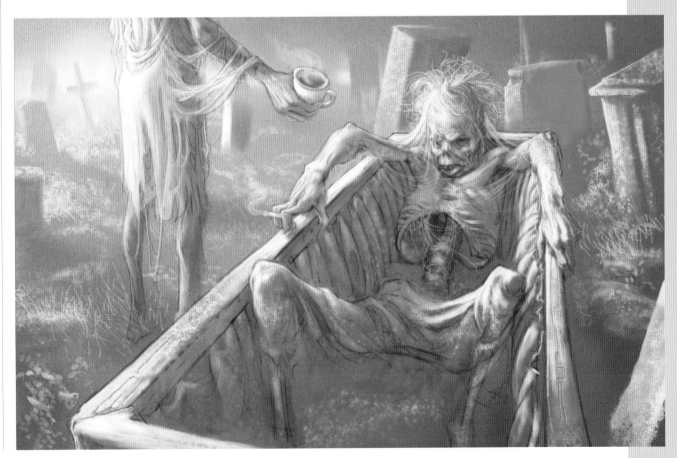

MEDIEVIL RESURRECTION

FAMOUS FOR ITS QUIRKY, goofy humor mixed with a dark Gothic style, *MediEvil Resurrection*™ is the third successful *MediEvil*™ title to be launched by the Sony Computer Entertainment's Cambridge Studio in the UK. Near the end of a game's project schedule the company is required to produce banners, T-shirts, posters, and magazine covers to promote the game. This particular image was designed as a five-foot banner for shop fronts.

A promotional image of this kind is very much the product of a concerted team effort. The "look and feel"

of the characters is a result of the important initial design work done by the team's concept artist during the game's early stages of development. The 3D artist who created this final rendered image adheres closely to the exact texture and lighting details that were carefully generated during the game's lengthy development process, in order to maintain its distinctive style.

In this composition, the Art Director wanted to epitomize the "hack and slash" nature of the game with the main character, Dan Fortesque, thwacking at the evil un-dead with his Vorpal Sword.

1 The image was first drawn in sketch form on paper. A number of ideas were explored until one was singled out for development, with all parties agreeing that it best captured the spirit of the game.

This design was then passed onto a 3D artist, who modeled, posed, textured, lit, and rendered the image using Maya 3D software. The 3D artist kept in mind the final image and used layers for extra versatility so that a graphic designer could later position lettering. It is quite common for type to be placed behind the subject matter.

All characters were modeled using a base polygon mesh which was kept as reference throughout the process for ease of positioning. The mesh was subdivided and smoothed, to make the models look more curved and organic.

2 The designer wanted the models to look as if they were made from real-life construction materials. For example, the armor was to look like plastic rather than metal and the bones were to look like modeling clay. A *Blinn Shader* was used on the bones to give a subtle, yellowish-gray shading effect; to represent light passing through them and giving them a porcelain-like translucency.

The woolly fibers on Dan Fortesque's red blooming sleeves were created using Maya *Fur*

and the cracked coal-like surface on the ground was modeled around (rather than behind) the scramble of skeletons, to give the impression that the zombies were breaking out of the ground. This texture was achieved using a black *Phong Shader* with a fractal-textured bump material. An *Incandescent Green Layer Shader* is added with a *Glow* attribute to create a lava-like feel. This green effect is rendered as a separate layer to give more flexibility to the coloring of the final image.

SOFTWARE **MAYA, MENTAL RAY, ADOBE PHOTOSHOP** 3D RENDERED IMAGE **JASON RILEY** ART DIRECTION **MITCH PHILLIPS** GAME STORY AND CONCEPT **CHRIS SORRELL** PRODUCER **PIERS JACKSON** WEBSITE **WWW.MEDIEVILRESURRECTION.COM**

Lights were added to cast sharper shadows.

A module in Mental Ray called *Final Gather* was selected to mathematically sample the area around the model's surface, so as to give it *Radiosity* (the effect of bouncing light, color, and shade).

Fog effects were rendered on a black background with the lighting turned off. Maya's *Volume Fog* shapes were placed over the heap of skeletons. The volume fog has a fractal noise texture running through it to give the fog a transient, cloud-like quality.

The global lighting map below consists of a sphere containing a color map, a *Key Light* and an *Uplight*.

(4) From below right to left, this step shows the typical layer order of a Photoshop file. First is a 2D-painted background sky with a few hills; then the main ground lies on top of this—this could be split into more levels, but as the characters are interacting with each other here it is difficult to separate in this instance. Two separate *Fog* passes have been rendered, to add depth and atmosphere, and these are overlaid as *Screen* modes.

The final image consists of six layers, compiled together in Photoshop. The first two layers of the hand-drawn sky and the hilly mid-ground are created from scratch in Photoshop. The third layer is the main foreground layer—Dan Fortesque and the pile of zombies—which is imported from Maya. The three remaining layers: the cracks, the *Volume Fog*, and the *Uplifting Spotlight Fog*, are all imported from Maya.

The two fog layers were given a *Screen* mode. *Screen* works as color tone additive—the darker the color the more transparent it will be, giving the image an ethereal

quality. After a few tweaks and corrections, it is ready for press. The final resolution turned out to be a huge 20,000 pixels high.

(3) The lighting was set up using a global sphere—an imaginary 360° light source. A *Moonlit Sky* was chosen and two green-yellow *Key* (spot)

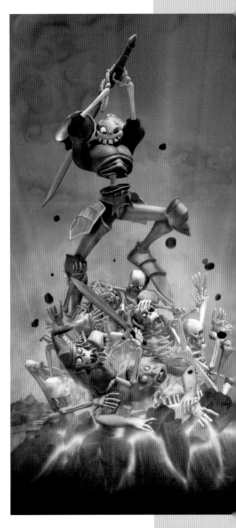

In pursuit of look and feel
The same careful adherence to the particular style of an image created by a large art team is just as important for an artist working alone, and the same thorough development of characters and environment will always make for a stronger and more convincing scene.

THE NIGHT GALLERY

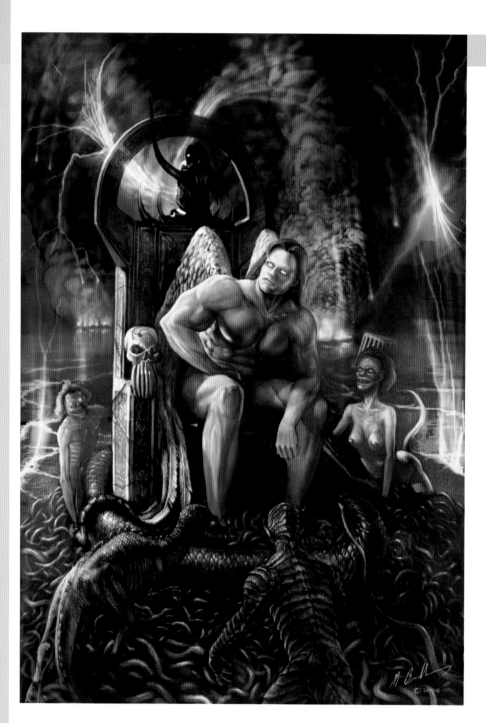

FALLEN ANGEL

A depiction of Hell, portraying the fallen angel Lucifer seated upon his throne atop a mass of writhing serpents. The throne is decorated with Cthulhoid forms, suggesting links with Lovecraft's pantheon.

ARTIST MATTHEW BRADBURY
SOFTWARE PHOTOSHOP

NECROMANCER

Rob Thomas' painting perverts traditional religious iconography to create an image that comes to us already laden with numinous power. This Gothic dark angel stands silhouetted in a church of shadow.

ARTIST **ROB THOMAS** SOFTWARE **PHOTOSHOP**

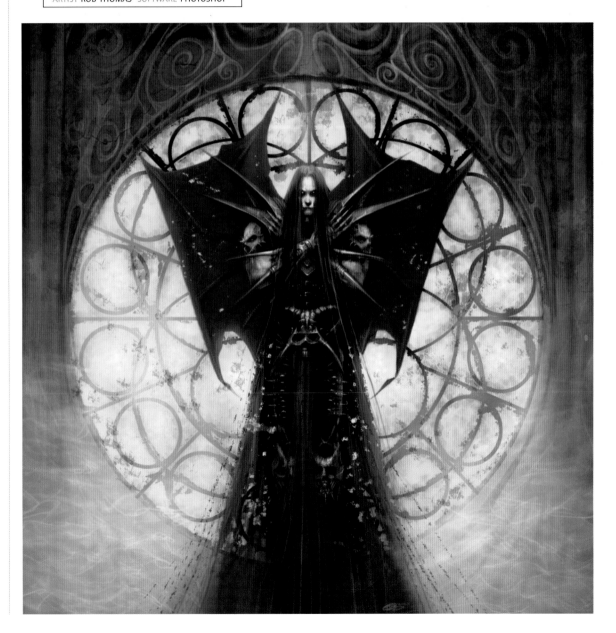

FRANKIE

Here's a subtly comical version of Victor Frankenstein's
unfortunate creation, in the midst of being shocked into
life. Nick explains his technique, "This was drawn on an
Intuos tablet, as is most of my digital work. The *Gradient*
backgrounds were done in Photoshop. In Painter I worked
on dark tonal *Multiply* layers using *Tinting Brushes* beneath
lighter tonal layers, building up detail using a combination
of Painter's very tactile *Oil Pastel Brushes* and *Pens*, and
anything else that took my fancy from the vast arsenal of
Brushes within the program. In the end there were many
layers, so it was a big file."

ARTIST NICK HARRIS SOFTWARE PHOTOSHOP, PAINTER

THE CREATURE

Returning to Mary Shelley's original source material, Mark
has depicted the existential defiance of the lone creation
faced with an uncaring universe.

ARTIST MARK GIBBONS SOFTWARE PHOTOSHOP

NOBLE DEAD

A modern vision of the vampire hunter, very much in the *Buffy the Vampire Slayer* vein, with a leather-clad look inspired by the film *Van Helsing*. The moonlit landscape and general Gothic mood recalls the classic Universal horror films of James Whale, suggesting the lonely Carpathian mountain regions of the cursed "land beyond the forest": Transylvania. The image below shows the work in progress.

ARTIST **MARTIN MCKENNA** SOFTWARE **PHOTOSHOP**

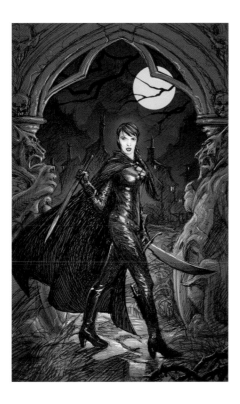

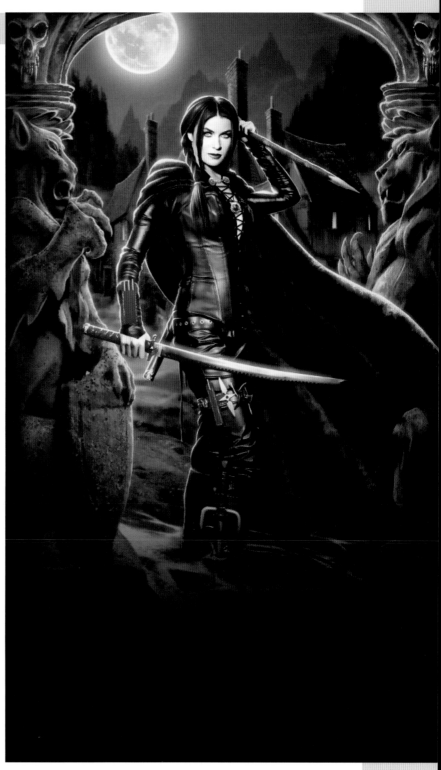

REALITY SHOW

This illustrates the unalleviated terror when stark reality sears itself directly into the brain. The human condition is here seen exposed, the eyes peeled open, unable to shut out the images bombarding the retina.

ARTIST GRZEGORZ KMIN
SOFTWARE PHOTOSHOP, POSER

2

SHROUD OF RED

"I wanted to get visceral with this one. I find the colors of decay in the human body are extremely beautiful. Nature always works with an interesting palette."

ARTIST **SAMUEL ARAYA** SOFTWARE **PHOTOSHOP**

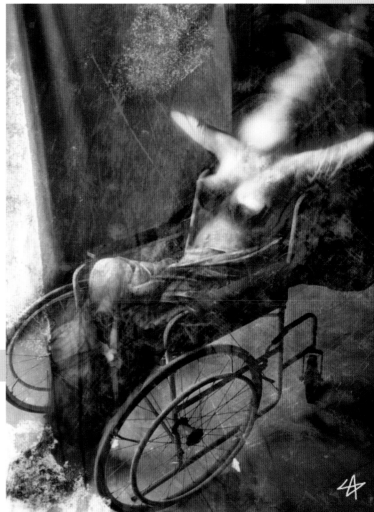

WITCH

"I'm fascinated by wheelchairs, as they speak of our limitations. While I created this I was reflecting upon the great work of Joel Peter Witkin. Lots of rusted texture helped to bring out the color of the piece, and there is a subtle purple permeating throughout. The flaming head was the result of a happy accident with layers."

ARTIST **SAMUEL ARAYA** SOFTWARE **PHOTOSHOP**

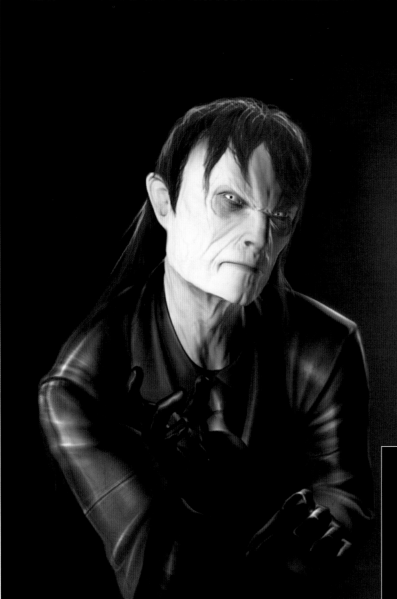

VAMPIRE CHARACTER

"I painted the hair in Photoshop for speed, as I had a number of variations to do on this character. The jacket is 3D-modeled, but I added the leather-look in Photoshop, again as I needed to show variations. This is for a short film—eventually he'll become a prosthetic for an actor. My greatest influences are the original *King Kong*, *Jason and the Argonauts*, *Star Wars*, Gerry Anderson, Ridley Scott, anything by Rick Baker, Frank Frazetta, Berni Wrightson, Stan Winston, Ralph McQuarrie, Alan Lee, Brian Froud, Gustave Doré, and Arthur Rackham. More recent influences include Peter Jackson's *King Kong* and *The Lord of the Rings*, *Hellboy*, ILM, Weta, Carlos Huante, Rob Bliss, Adam Brockbank, Dermot Power, Iain Mccaig, Doug Chaing, Miazacki, and Alex Ross."

ARTIST HOWARD SWINDELL
SOFTWARE ZBRUSH, MAYA, MENTAL RAY, PHOTOSHOP

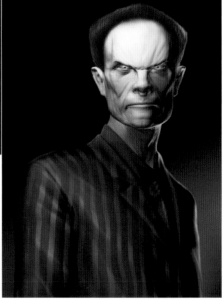

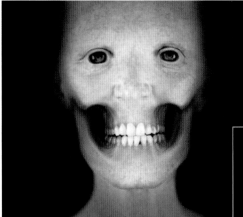

MOVIE CONCEPTS: HORROR CHARACTERS

"I'm trying to blur the difference between artifice and reality, using enough of both to keep the viewer off-balance and unnerved. Combining photographic and painted elements in this way creates an eerie feel."

ARTIST PETER KONIG SOFTWARE PHOTOSHOP

FREEZING DARKNESS

This possessed icy cadaver carries hints of the chilling female ghost figures from Japanese horror that have symbolically long, dark, lank hair. Japanese horror (or J-Horror) has produced some of the most effective supernatural imagery of recent years, in films such as the *Ju-on* series, and the *Ring* comics and films.

ARTIST **FELIPE MACHADO FRANCO** SOFTWARE **PHOTOSHOP**

NYARLATHOTEP

Nyarlathotep is the messenger of Azathoth and the other Great Old Ones in H.P. Lovecraft's "Cthulhu Mythos" stories. He appears in many guises, including Egyptian, and is described as the very soul of "gigantic, tenebrous, ultimate gods—the blind, voiceless, mindless gargoyles" that make up the Mythos. As such his evil is absolute, for he is not only the servant of these creatures, but their very consciousness.

ARTIST **DAVE CARSON** SOFTWARE **BRYCE, PHOTOSHOP, 3DS MAX**

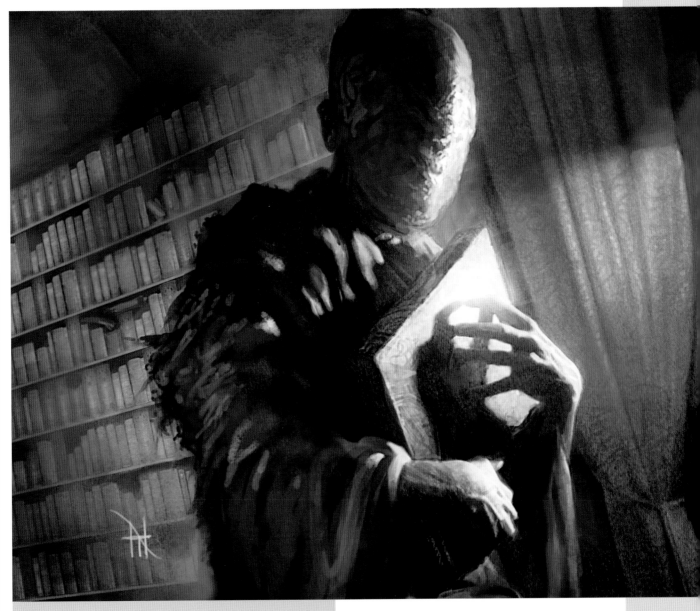

BEARER OF THE YELLOW SIGN

"The bookcase in the background is a composite texture that I made from multiple photos of old books. The face carries the strongest and most unusual color in the image to keep the viewer focused on it. I try creating suspense by playing with light and shadow. I also used a lot of contrast since this was to be printed at trading card size."

ARTIST TORSTEIN NORDSTRAND SOFTWARE PHOTOSHOP

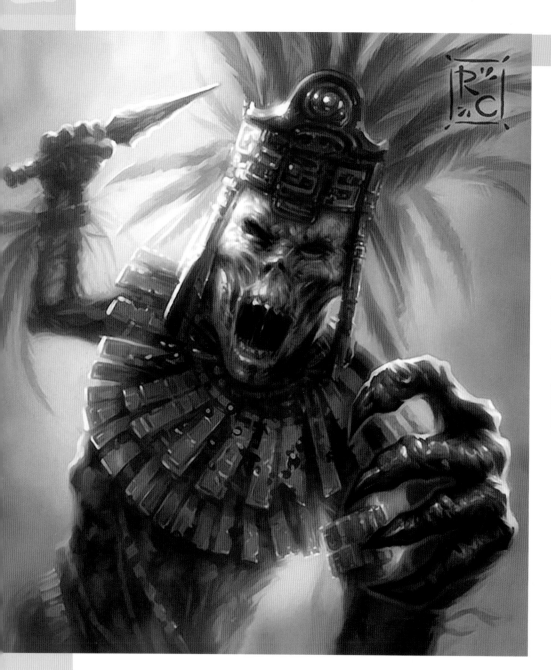

TEXACOTLE

A centuries-old Aztec warrior, his embalmed body withered and shrunken, yet filled with a horribly powerful energy to rise and guard his sacred tomb. Used less frequently than its Egyptian equivalent, the Aztec or Incan mummy can make for a formidable horror character, memorably in the low-budget Mexican "Lucha Libra" monster movies of the '50s and '60s such as *Robot vs. The Aztec Mummy*. In this depiction, Roberto confidently uses a loose, painterly style often employed in rapidly produced concept art.

ARTIST **ROBERTO CAMPUS**
SOFTWARE **PAINTER, PHOTOSHOP**

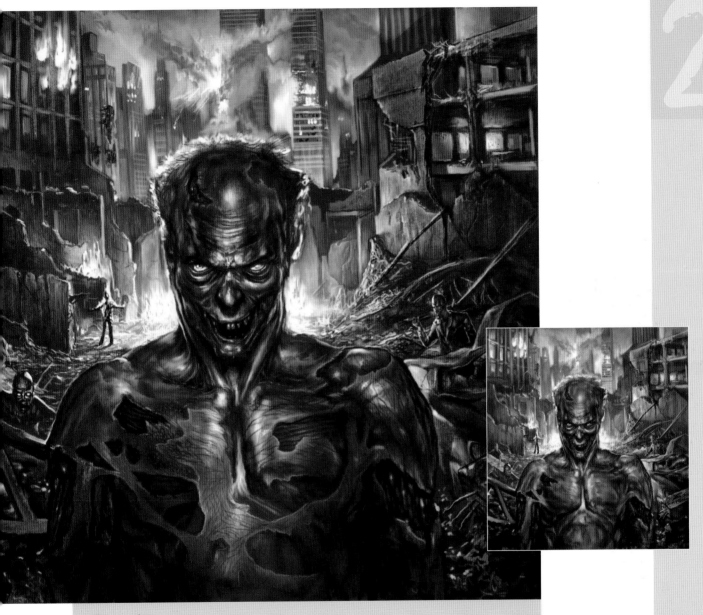

ZOMBIE APOCALYPSE

This powerful zombie character stands triumphant amidst the total destruction of the world of the living, to which he once belonged. The inset shows an early monochrome stage in the image's creation, and a great deal of detail was been added before Matt introduced color to the scene using semi-opaque *Brush* modes and *Layer Blending* modes. The *Dodge* tool is put to especially good use in this image, creating many highlights and generating a fiery golden glow to bring the flames to life.

ARTIST MATTHEW BRADBURY SOFTWARE PHOTOSHOP

3

CHILDREN OF
THE NIGHT

ONSTERS DEFINE THE VERY ESSENCE OF
HORROR IMAGERY; THEY ARE THE GENRE'S
MEAT, GRISTLE, BLOOD, AND BONE. HERE ARE THE
WEREWOLVES, GHOULS, GHOSTS, DEMONS, AND OTHER
MALIGN AND HUNGRY THINGS OF DARKNESS, SPAWNED
FROM OUR WORST NIGHTMARES TO PROVIDE A FEAST
FOR OUR IMAGINATIONS. THIS SECTION LOOKS AT THE
CHALLENGE OF EFFECTIVE CREATURE DESIGN FOR GAMES
AND MOVIES, AND THE DEVELOPMENT OF THE FRIGHTFUL
AND FERAL MONSTERS THAT POPULATE SO MUCH STRIKING
HORROR ILLUSTRATION.

INTO THE HOLE

MATTHEW BRADBURY IS A FREELANCE illustrator based in the UK. He has worked for a range of role-playing game publishers including Seaborne Games, Cryptic Comet, and Unbroken Games.

From a very early age he has loved horror films, and the young Matt would plead with his parents to let him stay up to watch them, often being scared silly by old B-movies. Nightmares ensued but he was hooked, and he would constantly draw monsters, especially werewolves; *An American Werewolf in London* and *Alien* remain two of his favorite films, and he finds them an ongoing inspiration. As part of his degree course in model-making for design and media, Matt was introduced to Photoshop and he immediately fell in love with digital art, although he found it held a steep learning curve. As he says, "I sketch digitally every day. It's a bit like working out in a way, the more you do the stronger you get—and that spurs you on."

In Matt's step-by-step workthrough, he reveals some of his painting methods in Photoshop, explaining how he creates a detailed grayscale under-painting that he then tints using semi-opaque *Brush* modes and *Layer Blending modes*.

"In creating *Into the Hole* I wanted to play on the common fear of spiders and small spaces. Spiders will probably give most people the shivers, and I was inspired to produce a claustrophobic image of someone falling into the clutches of a giant subterranean monster."

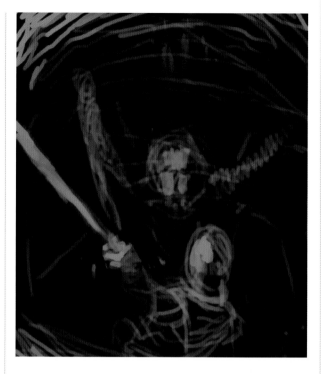

① With a black background in place, I begin by very loosely sketching with the *Brush* tool at various *Opacity* settings at 50–100%. The sketch is in gray tones on a separate layer from the background. This maps out my very basic composition.

Triggering phobias

Employing the imagery of common phobias can be hugely effective in the creation of provocative horror art. Draw upon our fears of things that slither and scuttle in dark places. Nowhere is this better illustrated than in H.R. Giger's designs for the life-cycle of the creature in the film Alien, *with the pale spider legs and coiling snake tail of the face-hugger, its adult form a visceral embodiment of all our fears of impregnation, birth, and death.*

SOFTWARE **PHOTOSHOP** ARTIST **MATTHEW BRADBURY** WEBSITE **WWW.BRADBURYILLUSTRATION.COM** EMAIL **MATTBRADBURY2000@YAHOO.COM**

3

(5) Now I start to flesh out some details and develop a feel for the lighting; applying monochrome tones with the *Brush* and *Airbrush*, and then using the *Smudge* tool to blend. I've altered the spider's pose to create what I think is a more balanced composition overall.

I don't really use any special *Brushes*, but these are my top three, as they are my most-used; a hard-edged tapering *Brush*, an *Airbrush*, and a non-tapering *Brush* that fades with Wacom pen pressure. I also use these same settings with the *Smudge* tool. Pretty simple, but the combination of these tools provides all the stroke variations I need to paint in the way I like. At this point the spider's head, in particular, has been fleshed out in more detail.

(3) After further playing around with the *Brush* and *Smudge* tools, I've changed the pose of the figure by *Flipping* it horizontally, and the composition is starting to shape up in a way I like.

(2) As you can see I'm not much of a draftsman! Rough squiggles and shapes are pretty much how I get going. I don't often use reference, as I like to keep things very loose at the beginning. I look for nice little shapes, and *Smudge* and *Erase* other areas, until I start to see shapes and forms that I like. As the various parts of the sketch are on separate layers, it's easy to *Transform* them and move sections around. Here I've *Rotated* the sketch slightly clockwise to achieve more dynamism.

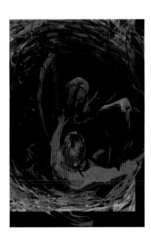

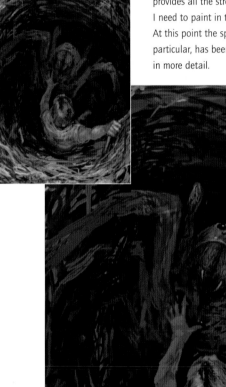

(4) Here I've slightly moved some of the layers toward the top left, bringing the figure closer to the spider, making the tunnel walls narrower, and generally giving a more claustrophobic feel. I've added drama by having the figure reach out an arm, as he tries to fend off the approaching horror.

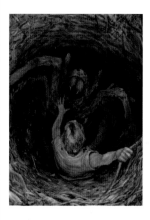 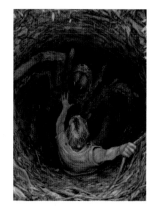

(6) As you can see I tend to work on an image as a whole, trying not to concentrate on the detail too soon in any one place. Working from dark to light, I refine various parts of the image and the spider finally acquires its leg hairs.

The tunnel detail, with its dry-looking roots and leaves, is now worked up to an almost finished state.

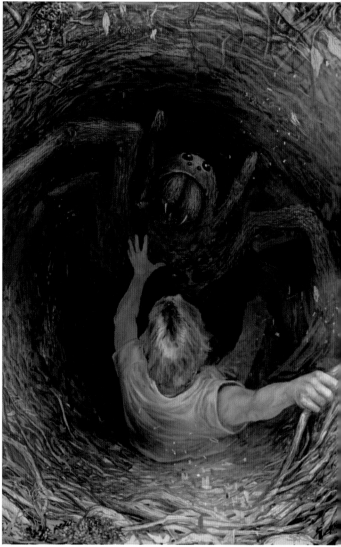

(7) In the final monochrome stage, before coloring commences, I define the figure more carefully, refining the hands and arms, hair, and the folds of his T-shirt. A few finer touches —the addition of falling bits of dust, debris, and hazy rays of daylight from above—are painted in using the *Airbrush*.

(8) After I've worked the image up to this well-defined level I will start to add the color. It's not good to have too much black or white in the image when starting to color it, as it just stays black and white and laughs at you! If I was going to leave an image uncolored, I would probably strengthen the highlights and shadows to give it a bit more contrast.

I start with basic colors and it seems crude at first, with the color looking flat and lifeless, but that's just the initial step.

3

9 My approach is to apply color using the *Brush* and *Airbrush* in *Color* mode at various *Opacities*. This gives a semi-opaque "wash" that tints the monochrome under-painting, allowing it to still show through the paint layer. *Brushes* in *Normal* mode can also be used on separate layers, and then the *Blending mode* and *Opacities* of those layers can be changed in *Layer Style* to *Color, Hue,* or *Overlay,* or whichever mode gives the desired effect after a little experimentation.

The tonal values of the under-painting provide most of the details of light and shade, so simple washes of color are very effective in giving an image its full-color life. Further highlights, such as those on the figure's hair and knuckles, can be defined by using the *Dodge* tool, which can lend such areas a golden glow of light.

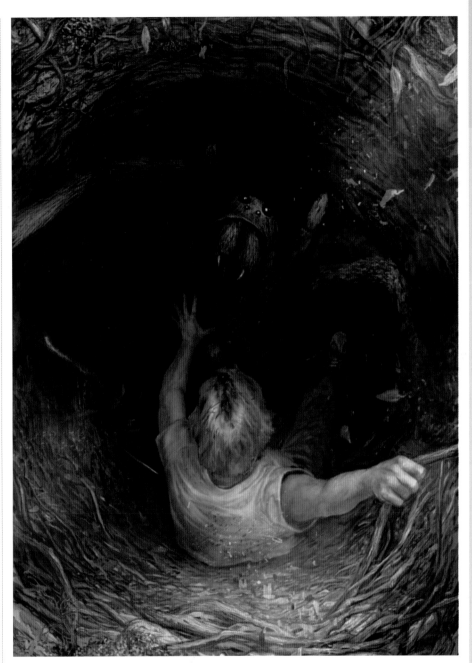

10 Here I've *Flattened* the layers, and adjusted the image's *Brightness/Contrast* levels to darken the shadows and dim the overall tone. After I'm happy with the colors I'll do a spot of fine-tuning. On mostly *Normal* layers I'll tidy things up and add in little details—in this case some extra highlights and falling twigs and leaves. It's hard to say when enough is enough, but I try to stop before it becomes overworked—when things start to look worse rather than better!

THE BEAST WITHIN

MELVYN GRANT HAS WORKED continuously over the years as an illustration artist in the UK, Europe, and in the USA, with all the major publishers. His subjects are wide-ranging, and his illustrations have featured in children's books and posters through to adult romance, science fiction, fantasy, and horror. Though he prefers working on books, he has also worked in advertising, animated films, prints, gift designs, and record sleeves. Until a few years ago he worked entirely with oil paint on canvas or board. Now all of his commercial work is painted digitally, as he prefers the drying speed of pixels.

Mel's approach to digital painting adheres very closely to the traditional oil painting techniques he used prior to his transition to working digitally: "Digital methods are now incredibly close to being the perfect painting medium. They have everything rolled into one. It's the fastest working method yet and my work now just gets better all the time. I'm keen to produce good digital paintings in a way that is as 'hands-on' as possible. All I've done is swap oil paint and canvas for pixel and screen, and I like to stick as closely as I can to the techniques I used in traditional painting—the way I worked prior to my conversion to digitalization.

"The program I mainly use is Adobe Photoshop and sometimes Painter. They are the only programs I've found so far that are suited to my working process, and all my artwork is painted using a Wacom tablet."

In this step-by-step Mel demonstrates his very traditional techniques applied to painting digitally, and as such it is a truly "tradigital" approach:

"This was a straightforward digital painting which I had a lot of fun doing. Apart from its original sketch, which was done with a soft blue Caran d'Ache pencil on a page of A3 paper, this piece was painted entirely within Photoshop using a Wacom A4+ tablet. I used the *Paint Bucket* tool to apply basic background colour. The other Photoshop tools I used were the *Paintbrush*, the *Airbrush* occasionally, and the *Smudge* tool. The *Paintbrush* puts on the color and the *Smudge* tool blends it, just like in oil painting. The *Airbrush* is to help with any large, smooth area that I can't do with the *Smudge* tool."

The importance of drawing
"The same skills and hard work must go into digital art as any other art if something worth looking at is to be created. Learn to draw before even touching a computer—there is no way of avoiding this, and you also need to develop an accurate eye. Just because you're using a computer doesn't make it an easy ride. You must still be able to see how your subject is really constructed and have the ability to put it down on paper, or on screen."

SOFTWARE **PHOTOSHOP** ARTIST **MEL GRANT** WEBSITE **WWW.MELGRANT.COM** EMAIL **MEL@MELGRANT.COM**

1 First of all the canvas is *Filled* with a very dark blue tone, to start creating a night-time scene. Over this I paint various complementary lighter purples and blues, in long, broad, horizontal strokes of the *Paintbrush* and *Airbrush*. Using the *Smudge* tool, the edges of these strokes are moved around and slightly blended into one another to generate uneven organic shapes, giving the impression of layers of dense nocturnal clouds or fog.

2 On a new layer I begin painting a castle on a cliff-top—a sinister, looming edifice in true Gothic horror style. I decide to have moonlight striking it from the right, so I work from dark to light, starting off with a silhouette and building up the tonal values with the *Brush* until I'm painting the highlights on the right-hand side of the towers and turrets. This process is no different to traditional methods. It doesn't take long, as it's quite a simple structure and my chosen color palette is very muted and limited. I add the tiny details such as windows and buttresses. Lastly, on another new layer, I lightly *Airbrush* some wispy clouds in front of the castle to help give a sense of distance and scale. I do this on a layer above so I can undo any strokes I don't like using the *History* palette, or alter the *Opacity* of the layer itself to make the cloud a little more transparent if I wish.

3 On another new layer I start to paint the very basic shape of my beast. It's mostly a big black hump to provide the foundation for its construction. Using the *Smudge* tool I drag areas of the black shape outward, to create the impression of clumps of spiky fur. Then, using a midtone brown color, I start to paint in some fur shapes in small tufts almost using a scribble motion, I follow this with a slightly lighter tone using similar strokes. Working from dark to light in this way, as with the castle, helps to bring an impression of three-dimensional mass to the form. The depth is suggested by the lighter tones looking like highlights in the tangled fur, picked out by moonlight. Next, again using the *Smudge* tool, I drag out these colors, mostly to the right, and they blend together to look like straggly lengths of fur caught in a wind blowing from left to right.

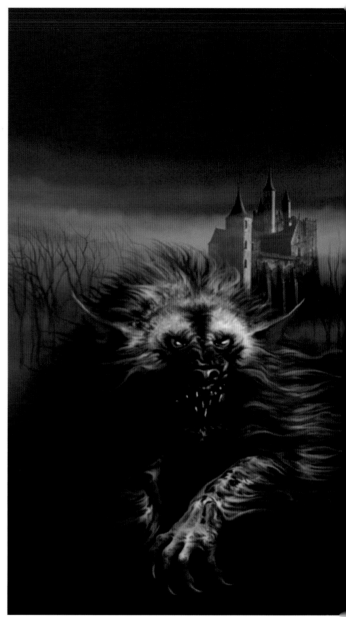

④ I've worked in more detail, and have painted the bank of wintry trees in the middle-ground with a fine *Brush*. All the basic foundation work is now done and the feel of the painting is right. It's at this stage that I know the painting is on course and I start to bring out the finer details, such as the trees already mentioned, and shadowy areas beneath the castle—this also provides a more solid background to surround the head of the beast, which I'm going to paint next.

I like to work the whole painting up to where it is waiting for those final few touches that make it complete. And, just like eating the cherry last, those touches are the most satisfying. It's the same approach as to building a house—work from the ground up. You can't put on the roof before you've built the foundations.

⑤ Now the overall mood is further developed and the finer details are being added. I've started to define the look of the beast, giving shape to its broad head set below its hunched shoulders. I'm after a sense of hulking mass, perhaps gathered ready to pounce. I've painted in its red eyes, pointed ears, and its nose, wrinkled in a snarl. I've started to put the final details into its fur, blown about in the breeze, and its clawed hand. The only major detail missing now is the finishing touch of the beast's ferocious jaws.

⑥ The finished painting. It's saved as a Photoshop PSD or TIFF file (depending on which the client asks for) at 360dpi in CMYK and RGB mode (I like to give a choice). I always work in RGB with the CMYK view on and with CMYK-compatible colors. Having the file in RGB seems to convert better through the software on my personal and inkjet printers.

RGB vs. CMYK and other good advice

"If you're working in RGB, make sure the colors are compatible with CMYK, especially the blues as they change when converted— that beautiful bright ultramarine could print as a dull slate gray. Photoshop has a little tag in the RGB sliders that appears in the bottom-left corner when a color is not compatible. Just click on it and the color will adjust. To sum up, any advice I have for the would-be digital artist boils down to these few points: become a good draftsman first, have lots of good ideas, and don't be afraid to put in plenty of perspiration. There is no way around learning to draw well, planning it out properly, and getting all your reference up-front—also cram as much RAM as you can into the machine you work on. Finally, and most of all, have fun with your art."

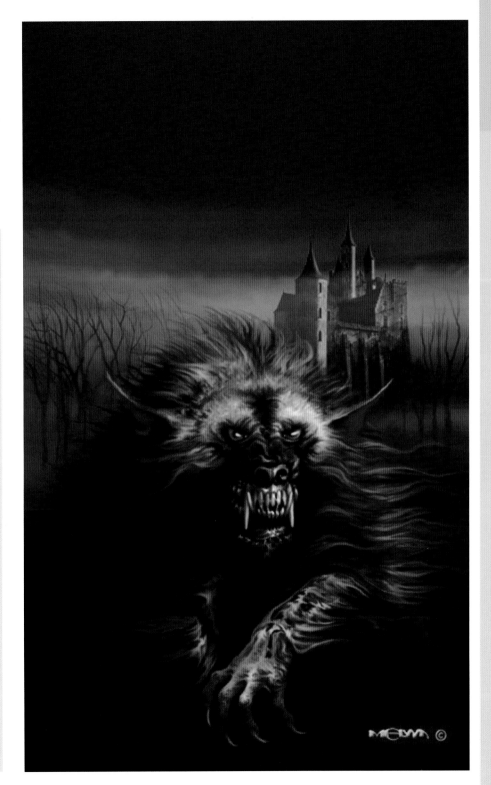

AZATHOTH

UWE JARLING IS A FREELANCE ILLUSTRATOR based in Germany. He has illustrated countless book covers, album covers, and video sleeves, as well as many technical and architectural illustrations for advertising agencies. In 2000 Jarling started to develop his fantasy artwork more seriously, and he created his first digital images. Since 2003 most of his work has been painted digitally, for clients worldwide.

"I did all my illustrations the traditional way before I fell in love with computer graphics. Because I do mainly 2D art it doesn't make much difference if I paint traditionally or digitally, as the painting process itself is very similar. Digital is simply faster than traditional, not in that you can paint faster, but digital media is, as it were, wet when you need it to be wet, and dry when you need it to be dry. If you have to change something it is much easier than using traditional media. Speed is very important when it comes to meeting deadlines, so if you do commercial illustrations working digitally is a big advantage. The only real disadvantage is that you don't have an original painting to hang on the wall. But as most of my work is done for print, an 'original' isn't so vital.

"Inspiration is all around, even wallpaper patterns inspire me—I just have to look, and there are faces, monsters, fairies, or whatever I imagine. The work of other artists is very important, and I love to look at fantasy and horror art as much as I love to paint it myself. I think everything that I hear, smell, or taste inspires me somehow. My problem is never lack of inspiration, it's the lack of time to work on all my ideas.

"I begin a piece of work by doing some very small, rough thumbnails to get an idea of the composition. Then I start the "real" sketch, sometimes with pencil on paper, or sometimes digitally as here, using Painter as my software of choice.

"The assignment for this work was for the *Call of Cthulhu* collectible card game from Fantasy Flight Games. It is none other than Azathoth himself, the greatest and most terrible of all the gods from the Mythos stories of H.P. Lovecraft. I received the following art description for the piece: "Hideous nuclear chaos. A city is destroyed in a flash, in something that looks partly like a mushroom cloud and partly like an enormous mouth."

Resolution and color conversion
"Always paint at high resolutions, 3000 x 4000 pixels or more if your computer can handle it. If you just work in low resolutions your picture may look pretty good on the screen, but it will look terrible when printed. Always work in at least 300dpi, which is the minimum print resolution. This means that if you want to do artwork which is 8 x 12" in print, the size of your digital picture has to be 8 x 12" at 300dpi, which is 2400 x 3600 pixels."
Offset printing requires a file in CMYK color mode. When converting an RGB file to CMYK you will most likely have to correct the colors a little. Use the Eyedropper tool to see if there is still color in the brightest part of your picture. If all colors are 0 at the brightest point you will need to add some color to give at least C=3, M=2, Y=2, K=0, or thereabouts—otherwise it will look poor in print, as the color will break at these brightest points so that only the paper is visible.

SOFTWARE PAINTER, PHOTOSHOP ARTIST UWE JARLING
WEBSITE WWW.JARLING-ARTS.COM EMAIL UWE@JARLING-ARTS.COM

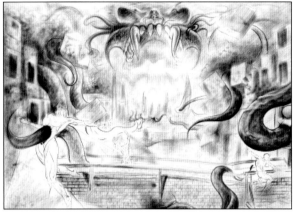

① I begin with some quick outlines to try to get a more or less believable perspective, along with anatomy for the characters. The tools I use for the sketch are Painter's *Pencil* tool and *Watercolors* for shading. They give a nice, interesting texture to begin with, and in some places they will show through even in the finished piece. To use Painter's *Watercolors* (those which create a new *Watercolor* layer) effectively, you need to work on a sufficiently powerful computer, otherwise it will struggle at higher resolutions. But if your computer is able to handle the *Watercolors*, play with them and you'll see that you can achieve amazingly natural-looking effects. I normally use the soft *Bristle* or soft *Camel Brush*.

③ I get rid of the construction lines, which were on separate layers, and I work on the anatomy of the characters to get them looking correct. I mostly construct my characters without clothes, as knowing how their anatomy works under the fabric makes it easier for me later. I'm still using the soft *Bristol Brush* in this step. I always work with my Wacom graphics tablet set up so that I have the soft *Bristol* on one end of the Wacom stylus, and the dry *Eraser* on the other end. In this way I can quickly change between applying color and erasing it by just turning the pen around.

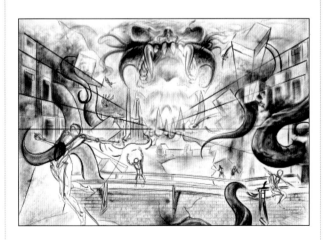

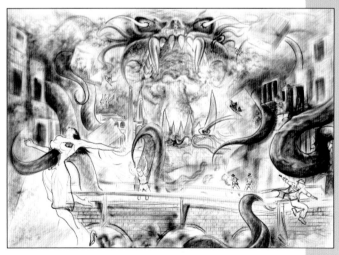

② I progress with the sketch, adding more shading and detail. I choose the soft *Bristol Watercolor Brush* and play around with the *Feature* setting. For the shading I set this very high, up to 10 and more, to give many single lines in one brush-stroke. I work very quickly with the strokes here, using them in all directions to create some nice spontaneous textures.

④ This is the finished sketch. It's still very rough, but detailed enough for me to start adding color. This is also the point at which I show the sketch to the client for approval. Once the rough is accepted, I can continue.

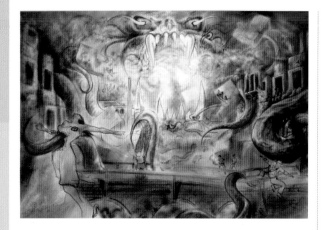

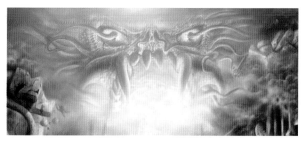

5 Now it's time to add the first color, applying a transparent glaze that allows the sketch to show through. I don't use any opaque colors at this point and I apply fairly loose strokes of color to gain a rough idea of what tones to use. I use the *Watercolor* brushes, specifically the *Diffuse Water*, always making sure to turn on the *Grain* setting, as this will ensure the paper structure is applied to the brush-strokes to make them look more interesting. You can use the *Papers* menu to easily change the type of paper, or its scale and contrast.

7 Now I add texture to the head of Azathoth, and introduce detail to pick him out from the background. I also start to work on the explosion clouds. A really cool brush for achieving this cloud effect is the *Artists Impressionist Brush*—playing with the *Bleed* and *Jitter* settings allows this *Brush* to achieve amazingly rough-looking effects. To blend my colors I always use the grainy *Water Blender* which I apply with the *Eraser* end of my Wacom pen, so that switching from applying color to blending color is quickly done by turning the pen around. Again, I always have the *Grain* setting on to include the paper structure.

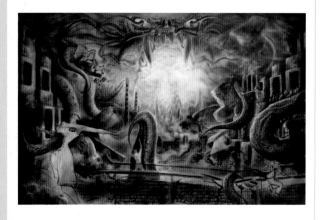

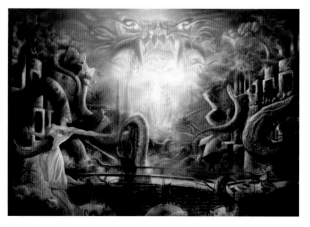

6 The general under-painting is now done and I start using opaque colors. From this point glazes and opaque paint go hand-in-hand. I continue to use *Watercolor* for glazes, and for the opaque colors I use *Oils* (mainly the *Bristle Oils*), and the *Pastels* here and there. Again, I always turn on the *Grain*, as the more structure and color variations—even if they are very subtle—the better. Color applied too evenly tends to look boring, making paint look like plastic; this is a good thing if you are looking for this effect, but not if you want to achieve a "traditional media" look with your digital paintings.

8 Here I'm adding more contrast and finishing one section of the piece after another. From now until completion, the tools I'm using are the *Watercolors* for glazes, which I also used here to darken the shadows, and the *Oils* for the opaque areas.

9 I add some subtle greens and blues in the shadows, and continue to add detail. To bring some color into the shadows I apply color on different layers and blend them together with very low *Layer Opacity* settings. I just move the *Layer Opacity* slider up and down until I'm satisfied, and then the layers can be flattened onto the canvas. I tend not to work with many layers.

(10) Lastly I make tiny, final refinements. I'm mostly happy with the overall feeling of the picture. Everything that's left to do, like final color corrections, I do in Photoshop. I use Painter for painting as I think it simulates "real" color better than Photoshop, and it "feels" more like real painting to me. But Photoshop is definitely the program of my choice when it comes to final color corrections, hue settings and so on. I make a CMYK file as required by my client; Painter sadly doesn't support CMYK, but maybe this will change in later versions.

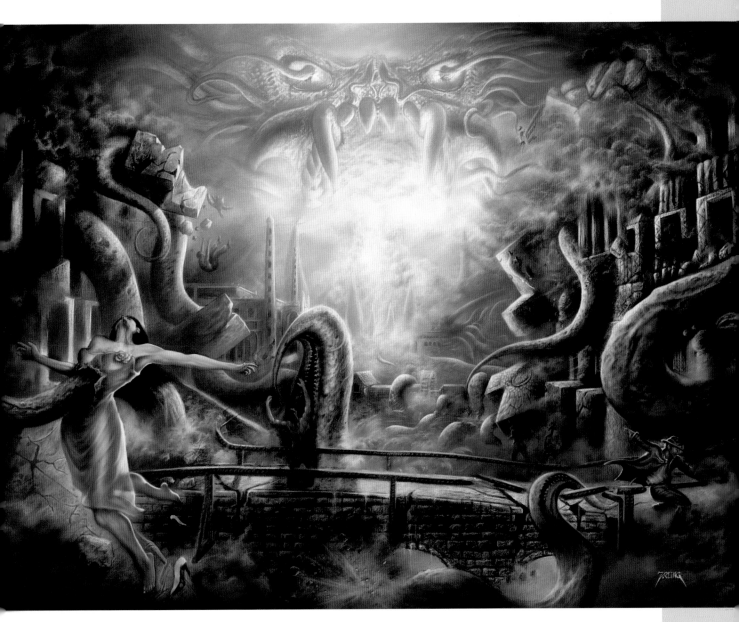

SKULLZERKER

KARL RICHARDSON HAS PRODUCED striking comic-strip and cover artwork for Games Workshop's *Warhammer Monthly* comic, the *Lonewolves* graphic novel being his stand-out work for that title. He has drawn the "Judge Dredd" strip and is working on other new strips for the comic *2000AD*, and he is also busy on projects with a number of CCG and RPG publishers.

This demonstration follows the design and painting of a creature for one of Karl's personal projects, a science-fiction horror comic-strip. "My idea was for a legion of zombie-like, berserker cyborgs, and I wanted them to be the ugliest, scariest, most hideously misshapen behemoths ever to grace a battlefield. I drew a series of quick sketches and chose one to develop further. These characters are ultimately intended for my own on-going project, so for once there were no deadline pressures. This allowed my approach to be flexible, but had this been a commissioned work with a tight deadline, I wouldn't have presented such a loose, unfinished sketch as this tutorial begins with. My intention from the outset was to invent the figure as I painted it, an experiment just to see how much fun—or how much of a nightmare—that could be."

Keeping it real

It's important to maintain traditional skills—even when working digitally, to stay in control of your art, and not to let the computer take over. Use the software as another tool, but continue to practice using traditional media: it's a good way to preserve the personality and individual style of your drawing.

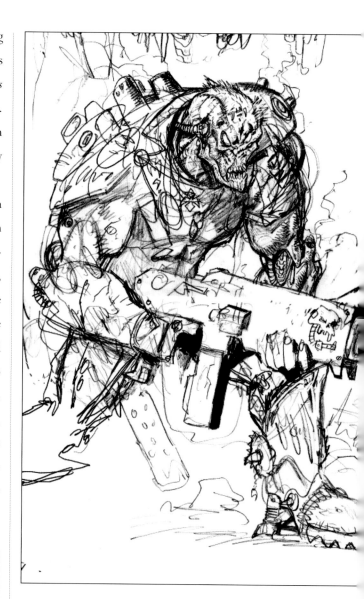

(1) My standard procedure is to scan a pencil sketch at 600dpi in grayscale, and then convert the result to RGB or CMYK, depending on what the publishing requirements will be. RGB is preferable as it gives a broader spectrum of color and is less hungry for memory.

SOFTWARE PHOTOSHOP ARTIST KARL RICHARDSON WEBSITE WWW.KARLRICHARDSON.CO.UK EMAIL KARL.RICHARDSON24@NTLWORLD.COM

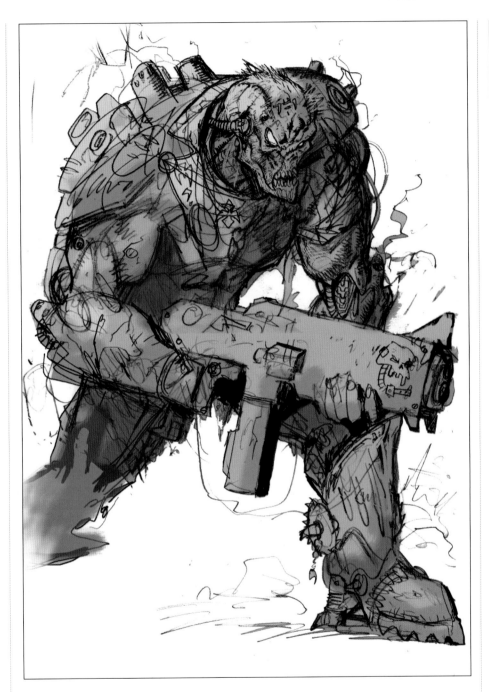

(3) I've already changed my mind about the color—he's military, and a zombie cyborg, so I make him greener. I now break with tradition and go straight for the head. Even with the *Undo* feature of the *History* palette, I would normally start painting an innocuous area of the picture while I was getting warmed up—a habit from my days of using traditional media. But the sooner I get this face right the sooner I'll feel happier about the image as a whole. Once I get to a stage where I'm satisfied with the head, I might go to any area next; probably an arm, but if I'm in the mood to paint the boot or the weapon I'll just go with the flow. I only use a small number of the *Brushes* available in Photoshop, and if I could do it all with one size of *Brush* I would. But two or three sizes do the job nicely.

(2) The next thing I do is to make a new layer to paint on. Using a *Brush* with the *Opacity* turned down to 50–60% I block in the figure with the predominant color I feel it will eventually be; in this case it's a sort of grayish brown. At this stage I only hint at a light source, because the setting will be a raging battlefield with multiple light sources coming from explosions, weapons fire, etc., and it's too early to plan those right now.

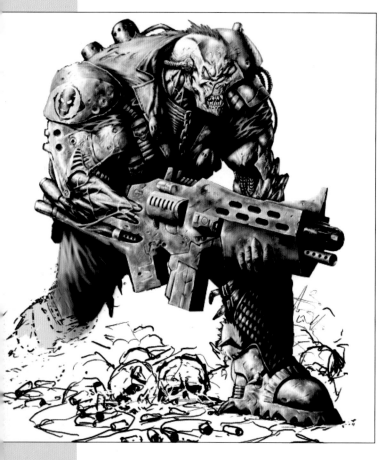

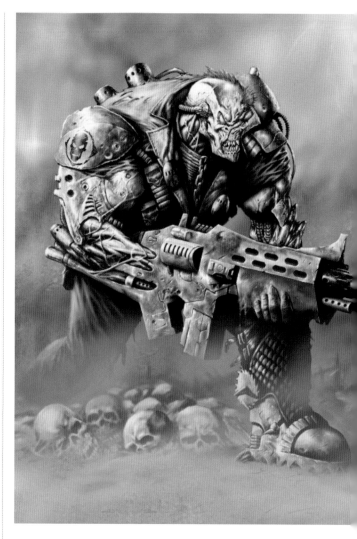

(4) I feel the figure should be given additional bulk, so I gradually increase this by painting shadows and definition in certain areas, but in the short-term I also widen the figure using *Transform*.

I decide to make the weapon "meatier" and make it an extension of his arm. I do this using freehand, *Airbrushing* on color in combination with the *Polygonal Lasso* tool to create the hard lines of the weapon.

(6) Now I can start thinking about the figure's setting. I've always liked the shots in *Terminator 2* showing the massive tank-treads crushing skulls. If I can introduce skulls into a picture I will, because I love that kind of iconographic horror imagery. Barbed wire and decayed equipment can decorate the ground, which I will paint directly into the scene on layers.

I want the background to be fairly vague, to give a sense of

action without too much detail, so I use silhouettes. I keep the foreground and background elements on separate layers for ease of adjustment.

I add details like the laser bombardment; painting one laser-bolt and copying and pasting it 15 or 16 times, slightly decreasing the size and contrast of each one to give depth to the bombardment. I paint smoke and an explosion on new layers.

(5) I've added the legion's insignias from separate files I made earlier. On straight or flat surfaces I just drag them in using the *Move* tool and then *Transform* them to scale, but on the slightly curved shoulder pad I also *Transform* in conjunction with *Skew*, *Distort*, and *Perspective*.

⑦ Up to this point I've tried to create the look of the figure's metal and fabric with just the *Brush* tool, relying on my traditional painting skills. It's important for me to maintain these skills and not let Photoshop take over, but I've recently created textures by taking digital photos of mainly walls and rocks, which I've then manipulated for a unique finish. To the armor and gun I apply one of my favorite "metal" textures, which actually started out as a photo of a mossy rock. I paint on a generous amount of blood spatters, and add gore under his boot and to a few other key places to help to convince us he's in the thick of a bloody battle. I then leave the picture for a few hours to gain some sort of objectivity. As a result I tweak a few things here and there, adding a shock of electricity to his earpiece. Finally, I make a new layer set at 5–10% *Opacity* which I *Fill* with an ocher color. This "wash" of color helps marry together the various elements in the picture.

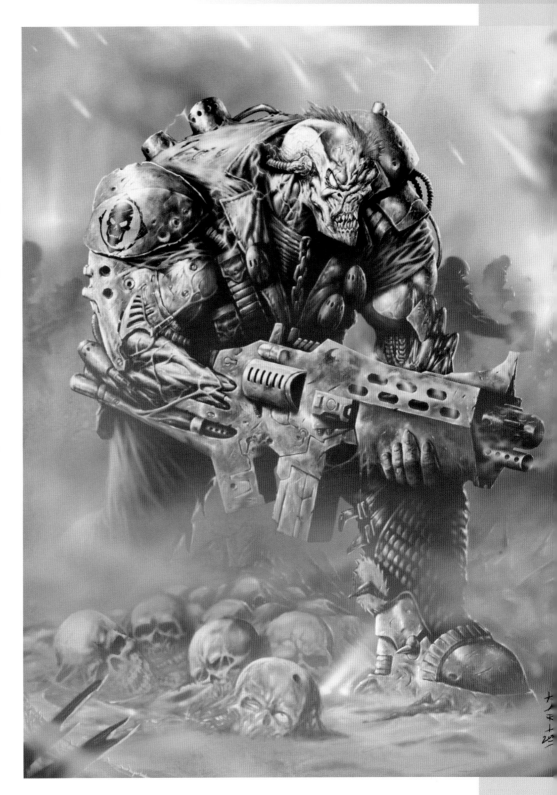

MUH HEED

FRAZER IRVING'S FIRST MAJOR COMICS work was a dark, Lovecraftian tale called "The Necronauts" for *2000AD*, which he followed with a variety of other strips exploring retina-searing psychedelic superheroes, high-contrast vampire horror, and heavy, brooding, painted drama. Frazer has also worked on the fictionalized adventures of Charles Fort in *Fort! Prophet of the Unexplained* for Dark Horse Comics and *The Authority: Scorched Earth* for DC Comics. He is currently illustrating Wizards of the Coast products, and continues to work on various strips for *2000AD*.

In this step-by-step Frazer shows us his painting techniques in the creation of this spontaneous and quirky horror portrait. "This piece has been done during a period of experimentation, in which I've created a number of works in very different styles. As an artist I'm aware of how a lack of variety in working methods can lead to creative stagnation. I chose to work up this 'floating head guy' idea because of its somewhat absurd nature, and also because of the utter weirdness of the concept. I reduced its silliness and increased the darkness, as I find dark subject matter much more fun to draw."

White-out

Block in a ground color so that your digital paints have something to work against, not least so that this overcomes the glare of the white "page," which can be as much of a psychological barrier as a visual one.

① First I do a quick sketch. A nice central composition and angle puts me in a good mood and sets up the tone for the image. I'm working at 600dpi here, on a 30" Apple monitor, so I'm able to work quite big on this. I'm also using an A3 Wacom tablet to give me quite a bit of freedom regarding the motion of brush strokes.

② I make a second layer and start to develop the drawing. It comes pretty quickly as I dig the subject matter, and I've had a fair bit of practice drawing emaciated faces for my regular work, so that this guy pretty much just draws himself at this stage. I retain the above light source and add in some hair for variety.

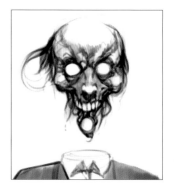

③ One golden rule I have for painting—digital or otherwise—is to block in a background so the paints have something to work against. The white page terrifies me and anyone who paints on white is either a) brave or b) stupid. Here I choose to chuck on a rather coarse and sickly green 'ground so that whatever I do on top of it, it'll have some energy. At this stage I'm using three layers.

SOFTWARE **PHOTOSHOP** ARTIST **FRAZER IRVING** WEBSITE **WWW.FRAZERIRVING.COM** EMAIL **ART@FRAZERIRVING.COM**

④ I've worked in some varying dark tones to bring out the form of this guy, but what I need is some contrast, hence the addition of the three eyes. Using dark ocher, I paint the eyes in really simply on a new layer, so that I can have something to focus on as I paint the rest of the stuff in.

⑤ The next step is to paint in the background on a new layer. I usually do this in paintings at this stage, as I feel it defines the form of the central figure and helps me with the lighting of the main subject. I invariably paint it in very loosely so that the inherent qualities of the paint add to the art. I like using this method to bring out the hair or features on the edge of freaky beasts such as this one.

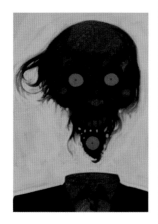

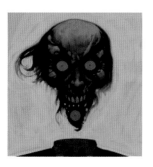

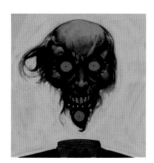

⑥ This is where I start to get into the nitty-gritty of painting. As with the previous steps I make a new layer. I have a tendency to use a lot of layers because I like the freedom they give me, although I always make sure to label them all. I start to paint highlights on the face using a bristled *Brush* in conjunction with a cleaner, round *Brush*. I keep the colors pretty dark and dull as the guy is meant to be spooky and un-dead. I then paint highlights on the hair, on a new layer. This utilizes tricks I learned in traditional painting, where three tones can say all you need to know about hair, and I keep the color rather dull as hair tends to reflect duller colors.

⑦ I quickly paint the body next and add a glowing red light emanating from his neck. The extravagant color helps to define the form of the face, and I also add some into the black shadows to give extra depth.

⑧ I make the eyes brighter—it maybe that the yellow eyes in Michael Jackson's "Thriller" video have something to do with this choice, and I like the cold staring nature of this effect. Finally, I add a new layer with stronger red highlights, in order to define the form even further, as well as to add to the general spooky weirdness of this guy.

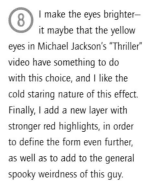

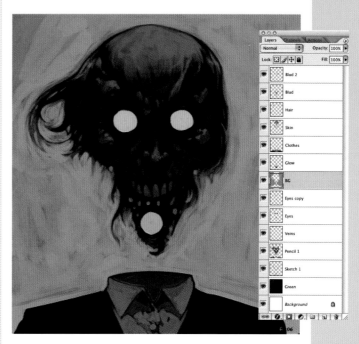

⑨ This is the final image, with its *Layers* palette above. I like the almost awful colors of the finished piece—in any painting I do, I look for opportunities for extra contrast as a way to bring more drama to the art, and that is exactly what the colors do for this picture here.

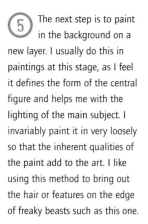

VAMPIRE WRETCH

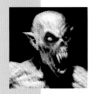

RICHARD FORCE IS A FREELANCE SCULPTOR based in Michigan. Working in the "pre-paint" collectible statue industry, Rick has sculpted comic-book characters for clients including Bowen Designs and Dynamic Forces, famous guitar heroes for Knuckle-Bonz, plus classic horror and fantasy subjects for many companies producing garage kits of model figures.

In this demonstration Rick documents his process of modeling a creature maquette, starting from a quick concept sketch and finishing with subtle coloring and texturing in Photoshop. Rick uses traditional techniques to create a clay sculpture which, once lit and photographed, leads to his final digital image. "My basic idea for this creature was a really feral and wretched Nosferatu-style vampire."

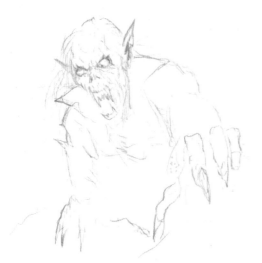

① This photo shows the wire armature, which will support the clay. After posing the wire, I'll begin to rough in the form.

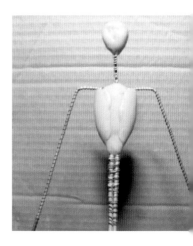

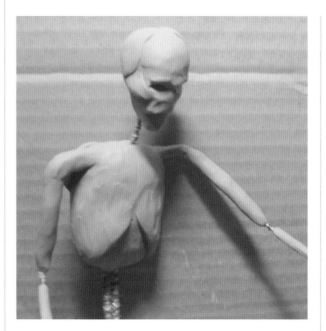

② Here the figure starts to take shape. Since I'm tweaking the basic design of this creature, I'm making subtle changes to the pose. Once I've arrived at a pose I like, I start adding the clay.

SOFTWARE **PHOTOSHOP** ARTIST **RICHARD FORCE** WEBSITE **WWW.FORCEPERSPECTIVE.COM** EMAIL **FORCEMODELS@HOTMAIL.COM**

3

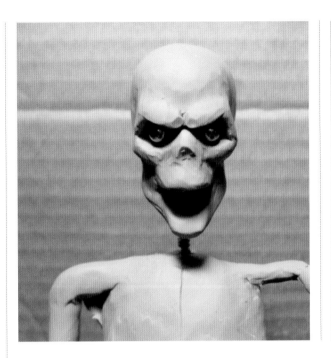

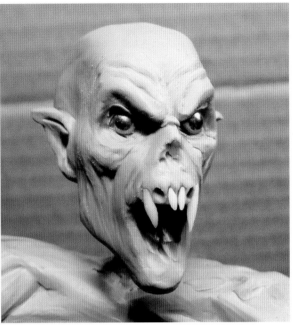

(3) I've started to establish the basic skull shape, and I've also added steel bearings to use as eyes. Normally I sculpt a character's eyes, but in this case I thought it would be beneficial to use the bearings, as their shiny deadness seems appropriate for the character.

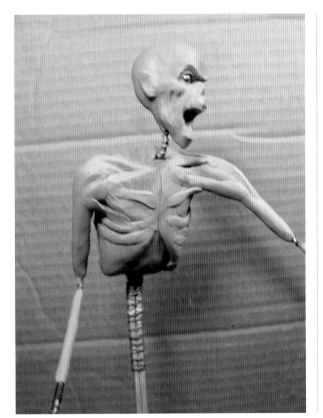

(4) I want this creature to have a very creepy and emaciated feel, so I've started to build him from the bones out. Then I'm just adding flesh and sinew in a subtle way, until I have the look I want.

(5) Now I have the general type of face I want for this creature, with very exaggerated features and sharp, fangs. The fangs were made from ivory colored Sculpey clay, so that they would look more realistic at this early stage of the maquette. Normally, I would have made the whole thing in the same color clay, but I felt the bearings and ivory clay would work nicely in this instance, as a basis for the digital color. The pointy ears reflect that basic Nosferatu look, of which I'm a big fan. I love creepy vampires.

3

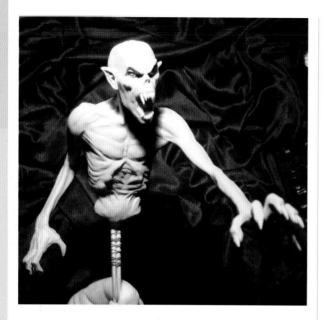

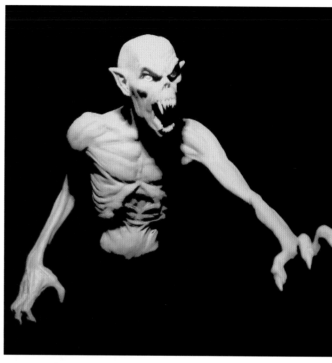

(6) Above is the photo of the finished maquette, and this will be the starting point for the digital finishing. I tried to get a moody shot, where I could make good use of the natural shadow.

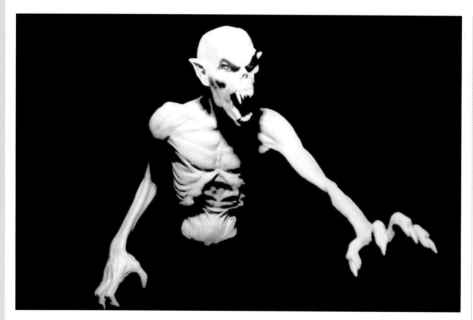

(8) Now I've added color to alter his flesh-tone, as well as some subtle yellow in his eyes.

I then go on to add extra detail. I introduce a wrinkled skin texture by bringing in sections of a photo of elephant hide, applied as *Overlay* and *Multiply* layers set to around 40% *Opacity*. I paint in simple highlights using the *Dodge* tool, and extra shadows with the *Burn* tool, blending things using the *Blur* tool. I add extra color with a *Brush* in *Color* mode, reducing the *Opacity* of the paint layers to maintain a muted palette.

(7) In this shot, the background of the original photo has been removed, so that only the figure is in the picture.

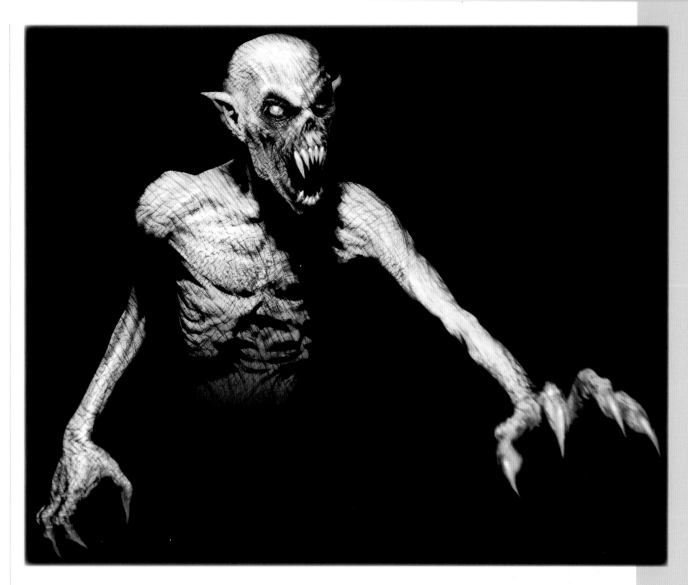

9 The finished image demonstrates what a simple and subtle way this is to take a piece from the "real" world into the digital realm. These Photoshop flourishes can of course be applied to an untextured digital 3D render in just the same way. Whether they're drawn, painted, or sculpted, there's nothing more fun than making monsters!

Texture and tint
Relatively simple 2D techniques, using tinting and imported textures on layers set to different Blending modes, *can very effectively add life to an untextured 3D render without the need for texturing the model itself.*

THE CREATURE

HOWARD SWINDELL STARTED HIS FILM career as an animatronics designer and sculptor in the late '80s for Bob Keen's Image Animation. He worked on many film projects there, including *Hellraiser 2*, *Nightbreed* and *Judge Dredd*, before working with Nick Dudman on *Star Wars Episode I*, *The Mummy*, *The Mummy Returns*, and *Harry Potter and the Chamber of Secrets,* among other jobs. At this stage he pursued more of a concept/3D artist role in film and TV on such projects as Gerry Anderson's *Captain Scarlet*, *Beowulf and Grendel*, *Watchmen*, and recently *Stardust*. Howard's game projects include Core Design's *Herdy Gerdy*, Sony's *Primal* and Climax's *Ghost Rider*.

In this overview of his methods based around the use of Pixologic's 3D-sculpting and painting program ZBrush, Howard demonstrates his workflow in the creation of an amphibious humanoid creature. The creature is partly inspired by the Gill Man, a character originally designed by illustrator Millicent Patrick for the classic Universal monster movie *Creature from the Black Lagoon*.

"When I first started using 3D software, the standard way of building anything was to effectively start with a cube and use the *Extrude* method to block out a simple shape, so that, by gradually 'pulling points,' you'd end up with a design. Then along came Maya with its paint-modeling tools and finally ZBrush. ZBrush revolutionized modeling methods, allowing the user to work with millions of polygons in real time, in a way that is much more like sculpting in clay."

Knowledge is power

"Learn all about traditional techniques, the anatomy of humans and animals, and make sure you see rather than just look at your subject. Have a broad knowledge of art history, as well as films and comics old and new. Always switch between methods and software to stay fresh and artistically exercised. Listen to your peers and learn from those you admire; always experiment—computers and software are only tools for you as the artist."

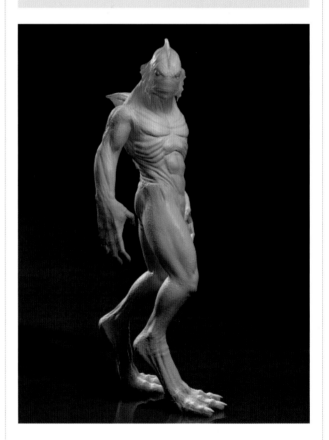

1 My first step in the creation of any character concept is to do some quick sketches, and a front and side elevation for a build in a 3D modeling program—either Maya or Lightwave.

SOFTWARE ZBRUSH, MAYA, MENTAL RAY ARTIST HOWARD SWINDELL EMAIL HOWARD.SWINDELL@TINTERNET.COM

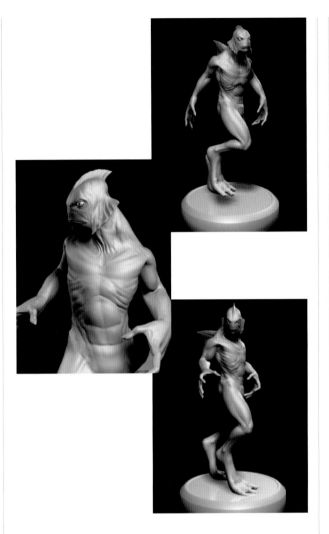

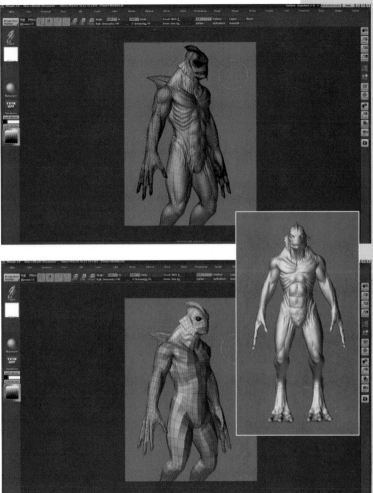

(2) I then use a concept base mesh to begin modeling—working this rough shape is akin to the general weight and feel of blocking-out basic forms in clay sculpture. I'll prepare all UV mapping to have a good layout for the displacement and other maps needed for the final renders. UV mapping tells the 3D software where to place the texture map on the surface of each polygon that the model is constructed from. Displacement maps are the type of texture maps used in rendering software to deform the model surface during rendering. Also it's a good idea to split the mesh into sets for later use as *Polygroups* in ZBrush. *Polygroups* are a way to select and isolate sections of the model, such as a limb, so that it can more easily be worked on. Lastly I save out a *Medium Polygon Resolution Mesh* that I'll import into ZBrush as a basis for sculpting. A *Medium Resolution Mesh* of around 6,000 polygons is more manageable than one with a million or more.

(3) Now time for the fun bit as we finally get to ZBrush. I discovered this fantastic piece of software when ZBrush 2 was released. I was an animatronics sculptor for a number of years in the British film and television industry, so when this software came along I found it really bridged a gap.

I import the base mesh saved in an .obj format from either Maya or Lightwave, increase the *Polygon Subdivide Resolution* to about 3 or 4 to give myself more polygons to work with, and start sculpting. Polygon subdivision is a system whereby the 3D software allows you to work on a more detailed model while retaining the simpler low polygon base. I gradually build up forms and broad shapes, increasing the subdivide resolution a step at a time to provide more working detail. It can also be very useful at this stage to do quick renders to test form and overall weight of the character.

3

④ Once I'm happy with the design I reduce the subdivision level back to a simpler model with fewer polygons while saving the detail I'd created in ZBrush as a displacement map, which can be used to recreate the detail in a 3D rendering program such as Mental Ray.

I then tend to paint color, bump, and specular maps by going between renders using one of my favorite rendering packages (Maya/Mental Ray, Lightwave, 3ds Max, Renderman, or Turtle) and returning to ZBrush to continue painting and enhancing the texture maps. Switching between software to view the coloring and paint job on a model is a good way to test how something looks in your render, and also to test for any detail that's getting lost.

ZBrush has many methods to achieve this kind of work; including the use of *ZSpheres* for modeling a base mesh, alpha maps for detailing (scales, wrinkles etc.) and *ZApp link* for extra texture control as a link to Photoshop/Painter etc. The Pixologic web site (www. pixologic.com) is one of the best around for information from a huge community of professionals and fans alike. Happy ZBrushing!

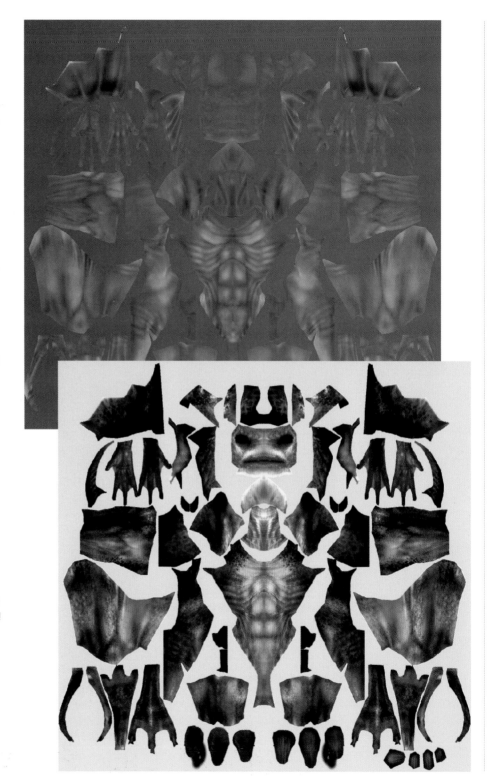

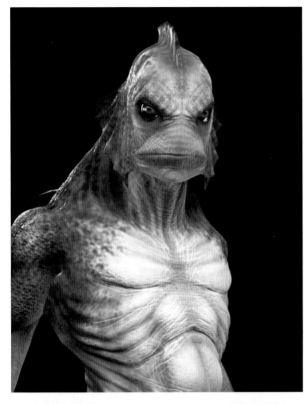

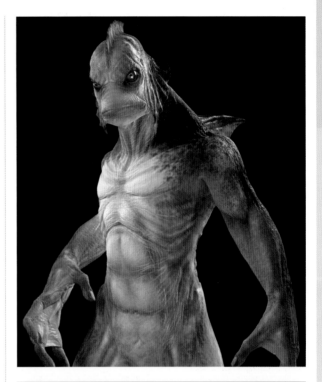

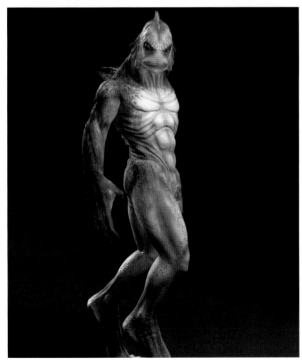

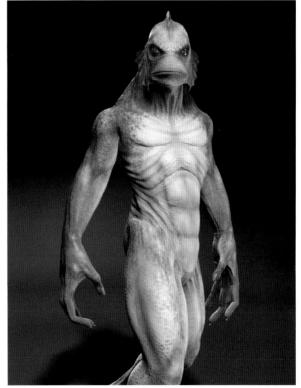

3

THE NIGHT GALLERY

THE HORN BUG

A devilish, Satyr-like fiend leers at the viewer, deriving sadistic pleasure from torturing his captive with an evil-looking parasite; his intention very likely to attach it to, or insert it into, some part of his victim.

ARTIST **MATTHEW BRADBURY** SOFTWARE **PHOTOSHOP**

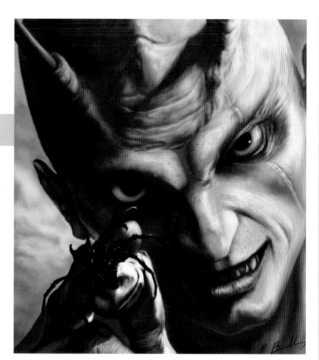

HELL DEMON

Red-skinned, snarling simian features, combined with curling ram's horns, tiger's teeth, and slobbering wet dog's gums, form a chimera that presents a traditional representation of a demonic face. You can almost smell the hot, brimstone breath.

ARTIST **MARTIN MCKENNA** SOFTWARE **PHOTOSHOP**

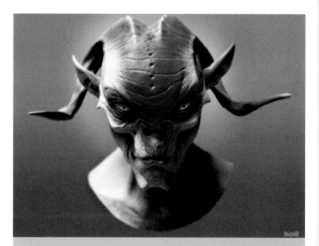

HORNED DEMON

Here, the same elements of a horned head create a demon who is less directly threatening but still distinctly unsettling. Pete has sculpted this bust in clay and finished it with digital enhancements.

ARTIST **PETER KONIG** SOFTWARE **PHOTOSHOP**

ANTLER JAWS

This creature is captured in a dynamic posture of venatic intensity, which brings out its predatory nature. The pose gives a sense of great power stored up for attack, and the frightening blankness of its expression disturbs because it regards us only as prey.

ARTIST **PETER KONIG**
SOFTWARE **PHOTOSHOP**

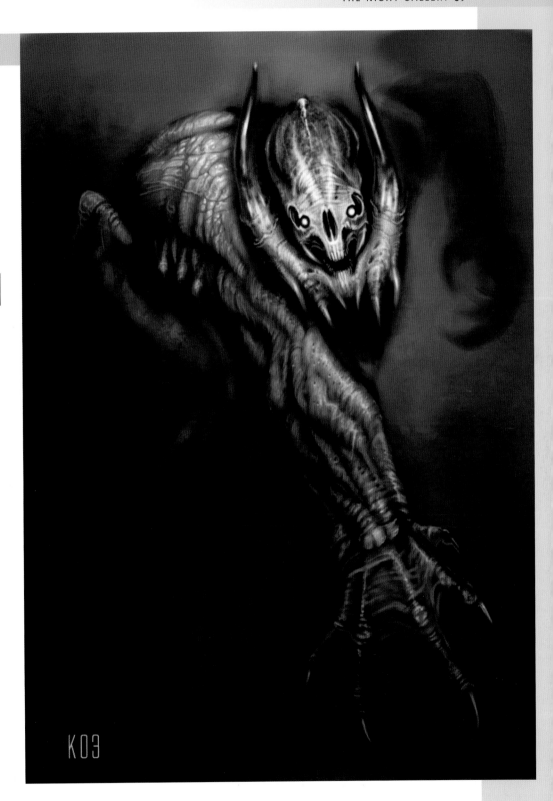

PAIN

This is one of a series of images in which Grzegorz has used a figure to embody a disturbed physical state, and here he shows pain as an archetypal underlying emotion of horror. The fingers of this faceless woman tear into her own flesh and slide beneath her own lacerated skin, attempting to stop the pain—or inflict more. Such body-horror images display a fascination with what's beneath the skin, and convey the strange beauty of the eviscerated human form, recalling the 18th-century anatomical wax marvels of La Specola in Florence, the flayed figures of Vesalius, and more recently the *Body Worlds* exhibitions of Professor Gunther von Hagens.

ARTIST GRZEGORZ KMIN
SOFTWARE PHOTOSHOP, POSER

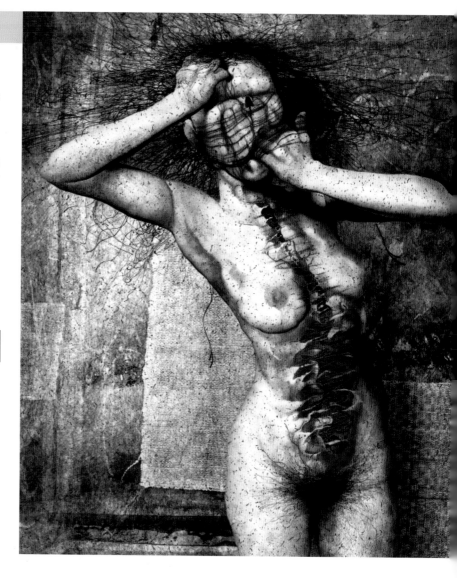

ATROPHY

"I've been really inspired by the *Silent Hill* series of computer games—they create a great sense of foreboding and uneasiness. While I'm not sure if I achieved that effect with this piece, I learnt that, while working on the series, several of the game's artists had seen my art and had been inspired by it. The influence had come full circle and it profoundly amazed me."

ARTIST JASON FELIX SOFTWARE PHOTOSHOP

DANCE MACABRE

Grzegorz has used anatomical elements from Poser, imported into Photoshop to be worked upon and arranged in an intricate, colorful pattern of flayed forms. The concentric shapes suggest frozen movement captured during a strange deathly dance.

ARTIST GRZEGORZ KMIN SOFTWARE PHOTOSHOP, POSER

HUNGRY DANCER

A grotesque skeletal figure dances, puppet-like, as though suspended—and fed—by strings that might be stripped arteries and veins, its gown streaming like a bloodied flayed skin. A modern *Masque of the Red Death*.

ARTIST GRZEGORZ KMIN SOFTWARE PHOTOSHOP, POSER

3

SCARECROW

A malevolent manifestation of nightmare itself, this ragged, flapping form of black tendrils, skeletal ribs, and rows of glimmering eyes coalesces to give potent surreal definition to nebulous dread.

ARTIST GRZEGORZ KMIN
SOFTWARE PHOTOSHOP, POSER

SPIRITS OF SILENCE

"This shows a werewolf in mid-transformation, disrupting three noise-hating spirits with the sound of crunching leaves."

ARTIST **TORSTEIN NORDSTRAND** SOFTWARE **PHOTOSHOP**

ZOMBI

Here Frazer makes strong use of digital black-and-white line-drawing techniques, inspired by the shambling corpses of *Shaun of the Dead*. This is caricature, altering emphasis to distort human features for horrific effect. The way the contorted undead faces emerge from the scratchy web of black lines recalls the heightened reality and pitch-black comedy of EC Comics.

ARTIST **FRAZER IRVING** SOFTWARE **PHOTOSHOP**

3

NOSFERATU

The old medieval depiction of the death's head is brought to us in this instance via German Expressionism and the inspiration of Max Schreck's iconic vampire, to create an image of an almost rapturous Death.

ARTIST DAVE CARSON
SOFTWARE POSER, PHOTOSHOP

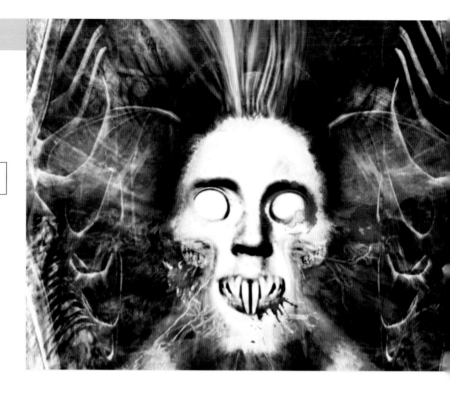

MY DEMONS

In this illustration Felipe has portrayed a group of ravenous living dead, hungry for the flesh of the living. Photomontage techniques lend themselves very well to realistic renderings of decayed skin and cadaverous skull faces.

ARTIST FELIPE MACHADO FRANCO SOFTWARE PHOTOSHOP

GUARDIAN OF HADES

"This piece was inspired by my favorite colors; red and green. At first, this started off as a concept for a straightforward zombie figure, but it ended up looking rather too elegant and regal. So I kept the body devoid of cuts and made its flayed face the main focus of the image. It remains rather strange and interesting, intriguing the viewer to wonder what's going on."

ARTIST JASON FELIX
SOFTWARE PHOTOSHOP

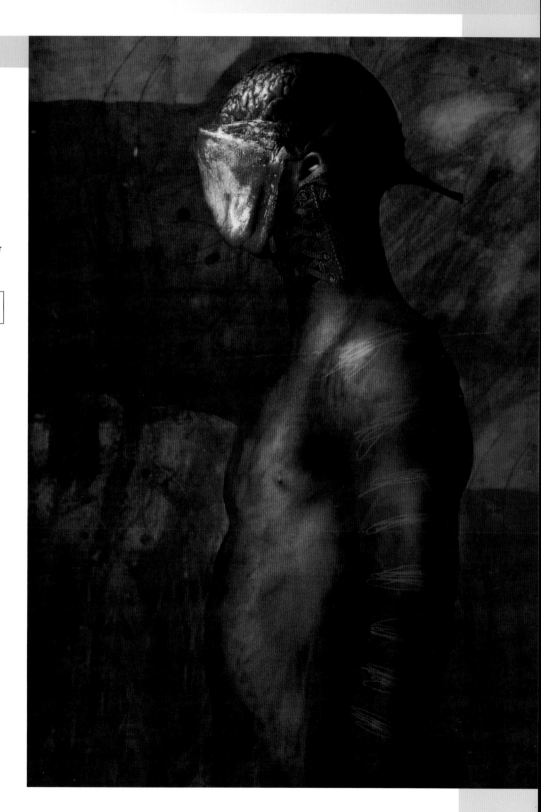

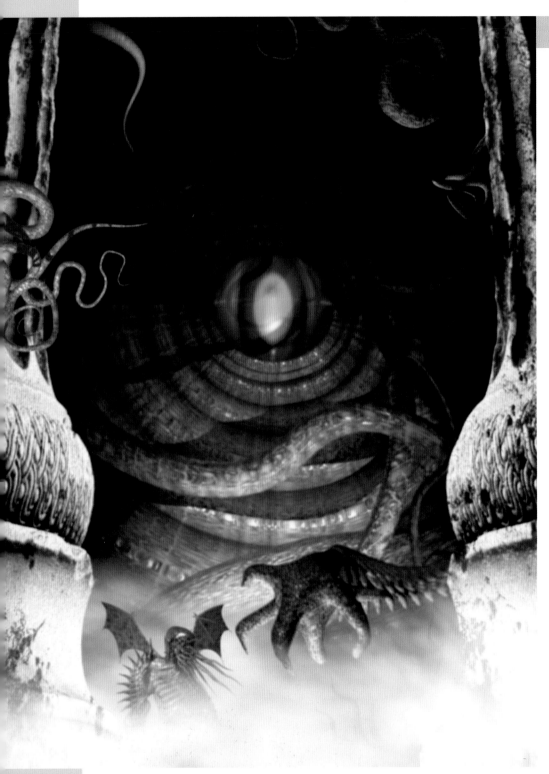

YOG-SOTHOTH

Peering down between mighty Cyclopean columns is the huge eye of the terrible alien god Yog-Sothoth. The rest of its horrible form is lost in the shadows, allowing us to imagine for ourselves what vast nightmarish shape it might take. This is another image directly inspired by the Cthulhu Mythos stories of Lovecraft, and it perfectly captures their atmosphere of cosmic terror.

ARTIST DAVE CARSON
SOFTWARE BRYCE, PHOTOSHOP, 3DS MAX

3

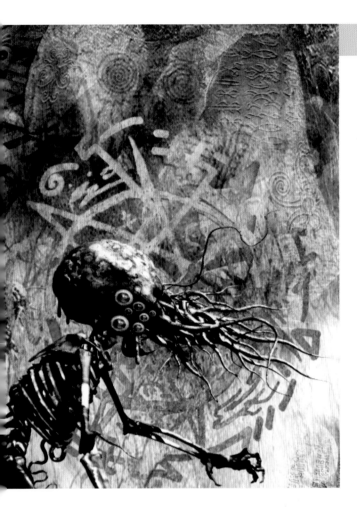

THE ELDRITCH DEAD

Through the murky depths of sunken R'lyeh stalks this skeletal tentacled horror. Revealing his inspiration for this creature, Dave explains, "My two greatest loves are Italian zombie movies and the weird fiction of H.P. Lovecraft, and I had great fun combining the octopoid head of Cthulhu with a bony corpse body. I just like drawing monsters."

ARTIST DAVE CARSON SOFTWARE PAINTER, BRYCE, PHOTOSHOP, 3DS MAX

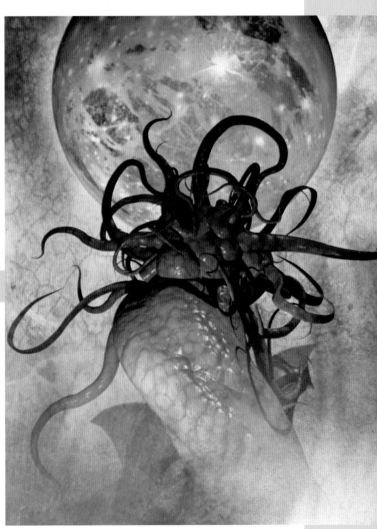

CHTHONIAN

Chthonians are described in Lovecraft's Cthulhu Mythos tales as immense earth-bound squid, with slimy, elongated, slug-like bodies, and they feature heavily in Brain Lumley's Cthulhu Mythos tale *The Burrowers Beneath*. Dave has portrayed the most important individual Chthonian, the gigantic Shudde M'ell, who is worshipped by the others.

ARTIST DAVE CARSON SOFTWARE BRYCE, PHOTOSHOP, 3DS MAX

3

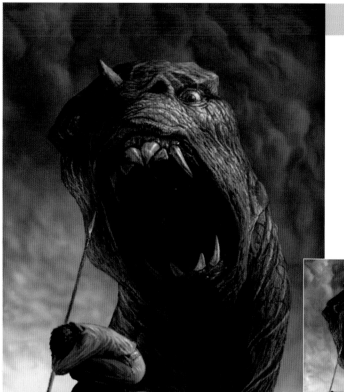

THE TRUE STORY OF PETER THE BRAVE

A monstrous worm rears up, roaring above the cowering figure of our hero; and perhaps, if fortune favors Peter, the creature is about to spear itself in its haste to devour him. The black-and-white inset image shows an early stage in the creation of *The True Story of Peter the Brave*; before the addition of finer details and color. We can see Matt's use of the *Smudge* tool here to create the basic cloud shapes before further refinement. He has then used the *Dodge* tool to give the clouds highlights and an added glow in the final picture.

ARTIST MATTHEW BRADBURY SOFTWARE PHOTOSHOP

THE WEREWOLF'S BITE

Torstein has used a painterly monochrome style that recalls the traditions of Victorian illustration. This grotesquely rangy lycanthrope subdues its human prey with ease, the victim utterly helpless in the grip of such raw power. The man's shotgun is spent, uselessly of course, because only a silver bullet can stop the loup-garou.

ARTIST TORSTEIN NORDSTRAND SOFTWARE PHOTOSHOP

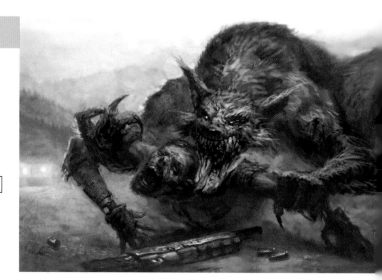

THE FAITHFUL

"This shows a werewolf returning to its tribe carrying human skins—hunting trophies that will gain it admittance to this lupine cult. The wolf's head symbolizes the ancestor of the tribe. The contrasting colors and tones on the upper part of the foreground figure make this the main focus. The creature is shown with its back toward us which increases its mystery and power."

ARTIST **TORSTEIN NORDSTRAND**
SOFTWARE **PHOTOSHOP**

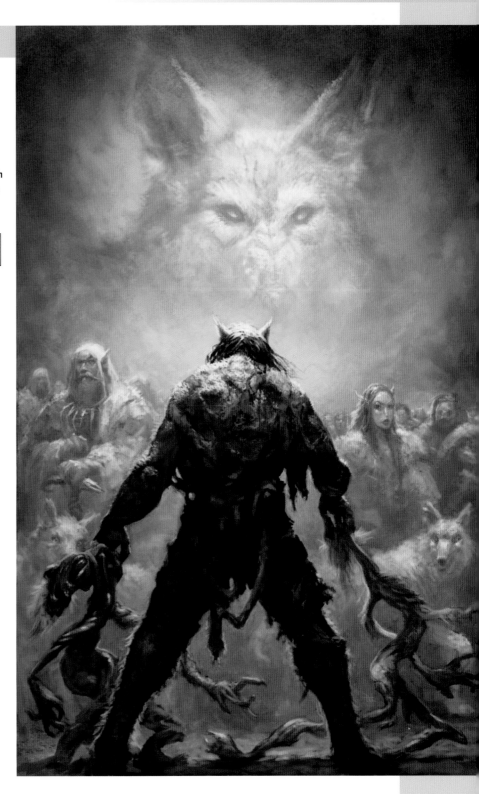

WHATEVER WALKS THERE WALKS ALONE

Haunted houses, gloomy chapels, dungeons and torture chambers, freshly opened tombs and catacombs, and ancient and modern cities of the dead. From the castles of Dracula and Frankenstein, to the New England Gothic of the *Psycho* house, the sagging gambrel roofs of Lovecraft's legend-haunted Arkham, or the cyclopean tombs of sunken R'lyeh; such buildings of fear provide the cornerstone of horror settings. This section examines the construction of weird and forbidding structures, laying the foundations for edifices of horror.

THE FORGOTTEN SPELL

THIS IMAGE WAS CREATED for the cover of *The Forgotten Spell* by Louisa Dent, the first of the "Spellcaster" gamebooks published by the Wizard imprint of Icon Books. The art editor wanted me to create a vignette that could be positioned in the center of the cover, allowing space for decorative titling to be positioned above and below it, and for a texture or pattern of their designer's choice to go behind. We decided on a roughly circular design, and to show a dark, Gothic scene that would allow me to depict three major elements from the story: a sinister city street at night; creeping tendrils of vapor that have a life of their own; and a spell-book of dark magic.

I wanted to construct the image fairly simply in Photoshop, and present the publisher with a layered file that would allow their designer to adjust certain parts of the image as necessary.

A flexible image
Layers are a wonderful tool, not only for preserving flexibility during the creation of a painting, but importantly for presentation to a client. It's worth considering the preparation of a layered file for final submission, so a publisher has greater freedom when working with your image—for example to insert parts of a logo between foreground and background elements.

1 I've quickly drawn this monochrome rough within Photoshop, using just the *Brush* tool on a gray background. I've always been most comfortable with line work of any kind, and I enjoy this sort of scribbling in Photoshop, due to the speed and ease with which I can quickly and cleanly make adjustments by *Erasing* and re-drawing. The basic hard-edged *Brush* tool doesn't provide a means for very expressive marks, but it's adequate for a rough sketch of this sort. I sketched the vapors on a separate layer, and used *Drop Shadow* in *Layer Styles* to give them a bit more smoky body and depth. I added some highlights in white to pick out certain parts of the scene, and with the white pentacle on its own layer, I used *Layer Styles* to quickly give it an *Outer Glow*. These embellishments were just to give the publisher a quick idea of how the image might develop.

SOFTWARE PHOTOSHOP ARTIST MARTIN MCKENNA WEBSITE WWW.MARTINMCKENNA.NET EMAIL MARTIN@MARTINMCKENNA.NET

(2) After discussions with the publisher and their designer, I've added a thorny border to the rough image on a new layer; the idea being to have the tendrils of vapor creep out over this circular frame. This will now provide a base on which to start creating the final artwork; so here goes.

(4) Quite a lot of detail and texture have been added to the building, and I've put a glow of orange light in two of the windows, on separate layers. Having the window areas on these separate layers means I could easily *Select* their shape for *Airbrushing*. The leaded frames were drawn using the *Line* tool, again on separate layers so the lines were easily adjustable. I've also now blocked in some flat color in the other areas of the street.

(3) I've started by blocking in some basic flat color with a hard-edged *Brush*, on an *Overlay* layer so that the lines show through. I've painted in the areas of the half-timbered house on the left, and the streetlight in front of it, and I've also added a wash of color on the cobbles.

My habit is to concentrate on individual areas of a picture, rather than work up the image as a whole. This is something that stems from my years of drawing with nib pens, where inking starts in one area and slowly spreads, detailing one section of a picture at a time.

THE LAB

ROBH RUPPEL BEGAN HIS CAREER as an industrial designer but soon succumbed to the call of the darker arts, having a natural predilection toward the more macabre. He works in the motion-picture industry now as an art director, but still occasionally recreates the dimly lit worlds that his poor tormented soul hungers for. When not working on films, he tries to get the feverish demons that share his brain to show themselves on bits of paper and in small dark digital files. Somehow, he also manages to teach at his alma mater, the Art Center College of Design in California. His life ambition is to be David Selznick, Edgar Allan Poe, and Raymond Lowey combined; a goal that he is well on his way to achieving.

In the first of his two demonstrations using Photoshop, Robh paints an atmospheric, blood-spattered basement lab scene which, with its elevated viewpoint, benefits from careful attention to three-point perspective.

Loosen up

It's best to start off a painting in a loose way, and then slowly begin to tighten up details. Starting too tight hinders your freedom and can severely limit possibilities. The old painting adage "Start with a broom and end with a needle," is applicable here.

② This is where I begin to refine the initial design. I start sub-dividing the individual shapes and try to make them look more interesting. Two things are happening here. The first is about working the abstract shapes and tones. I look at it as a design exercise—am I making an interesting pattern? I look at it in terms of form in space too— are the corners turning correctly? Are the details on the side plane staying on the side plane?

① The first thing I do is to block in the basic composition in simple tones to establish the design as quickly as possible. The idea here is to get an approximation of the final painting as fast as I can so I can see where it's going. If there are any big changes they happen here, while it's still easy to make them before I get caught up in the detail. Everything is judged purely by eye at this point, and there is no formal perspective grid.

③ I continue to do more of the same. Here I'm evolving the shapes as well as the lighting and I'm starting to add a little "bloom," or an over-exposed feel, to the light.

SOFTWARE **PHOTOSHOP** ARTIST ROBH RUPPEL WEBSITE WWW.ROBHRUPPEL.COM EMAIL RUPPEL@EARTHLINK.NET

4

(4) Here I adjust the whole color scheme to be more blue using *Color Balance*, and I've added an additional light in the hallway as it needed a little more interest there. The perspective and light direction is beginning to become more accurate at this point. I find it's better to start off loose and then go in later and begin to tighten things up more. If I start off too tight I'm less inclined to be free with the piece and you want as many possibilities in the beginning as possible. The painting so far is about 80% direct painting with 20% color and value changes done in layers. Sometimes I might use a *Color* layer, or sometimes a *Multiply* layer to add a few dark accents. The tile grid on the floor was a texture that I tipped-in using the *Transform > **Distort*** feature while referencing my perspective grid.

(5) Here I'm showing you my perspective grid. This is where I true everything up. It's a basic three-point grid, and by using a few colors it's easier to keep track of which line goes to which vanishing point. Things were only a little off but it doesn't take much to get the "something is wrong" feeling. This step is really important. It might only be a 5% change but it makes the painting feel 100% better!

(6) The final step (below) involves a few small color changes and a bit more detail, mainly the blood on the floor. Now we know something really bad happens down here, and we definitely want to avoid it.

HOUSE OF FLIES

SAM ARAYA IS A FREELANCE ILLUSTRATOR based in Paraguay. He has provided cover and interior art for many publishers, including White Wolf, Atlas Games, Visionary Entertainment, Arc Dream, Flying Lab Software, Eden Studios, Pagan Publishing, The Apophis Consortium, France's 7th Circle Publishing, and Germany's Feder & Schwert. He has also designed and illustrated various album covers and posters for heavy metal bands including Cradle of Filth.

In this demonstration Sam shows his use of photographic material, incorporated as layer *Blending modes*, to bring additional texture and atmosphere into his stylized image of a sinister house.

"I decided to avoid being too specific with the architecture of this haunted mansion, as I felt that a more impressionistic approach might work better here, leaving the viewer to imagine their own sinister details. I wanted the emphasis to be on mood, and to create a dark, Gothic fairytale tone."

"I'll use that one day"
Building a comprehensive reference archive of photos results in an indispensable resource for every sort of useful detail and texture; to either paint or draw from, or to import directly into an image for surprising effects. Arm yourself with a digital camera at all times, and be on the prowl for useful and inspiring material.

1 The image has been constructed in Photoshop as a monotone photomontage. I wanted to create something very stylized and angular, and parts of the image are subtly repeated, to give a sense of visual rhythm. The main roof shapes are triangular, yet there are some small breaks in their form, texture, and lighting to add interest. Up to this stage I've used mostly medium and dark color values, as I'll leave the highlights until last.

The trees are photos of dead trees I've manipulated using *Image > Adjustments > Threshold*, and each one is on a layer set to *Overlay Blending mode*. I play around with *Contrast* to create some depth. My main aim is to add visual texture, and build an impression of foliage.

The ground is simply painted with a round *Brush*. Using the same method as applied on the trees I added decorative elements to the sides of the house, mostly spiked railings and ornaments so it would look even more uninviting. To make the architecture weirder-looking I distort parts of it using the *Edit > Transform* tool, until the mansion gives the impression of having a roof that is too big for its foundations.

The structures on the left could be telephone poles, or they could be crucifixes. A little symbolic reference coupled with some ambiguity help to make a picture more interesting, and this subtle religious imagery adds to the somber mood.

SOFTWARE **PHOTOSHOP** ARTIST **SAMUEL ARAYA** WEBSITE **WWW.PAINTAGRAM.COM** EMAIL IMAGICA1666@YAHOO.COM

2 After *Merging* all the layers I've worked on up until now, I introduce a photo of some dramatic clouds at dusk, on which I've increased the *Contrast*. I set this new layer to *Multiply*, and the whole scene darkens a little too much, and emphasizes the angular remnants of earlier untidy layer work, so now I've some things to fix.

I *Duplicate* the layer containing the clouds, but this time I set its *Blending mode* to *Overlay*. Problems solved! As a plus, both layers subtly influence the tonal values of the house and lighten it.

Importantly, I chose to play around with layers instead of completely erasing or painting over the problem areas. I like to leave small traces of "imperfections," as it adds character to the picture, and gives the viewer a glimpse of technique. In an odd way it may be compared to being able to see the loose brushstrokes in a traditional painting.

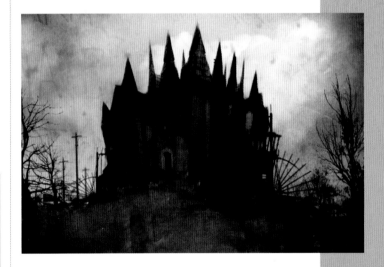

4 For something to simulate the grain of old photography, I use a picture I took of a very old cardboard box that I found on a junkyard. The box had suffered many trials to achieve a great level of texture, and I applied additional grain using the *Noise* filter. This layer goes over the rest, set to *Soft Light*.

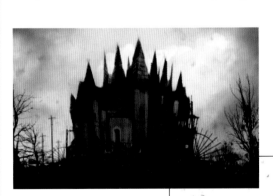

3 Now I want to bring in more texture, scratches, dust, and visual "noise." I want to evoke the feeling of an old photograph, to recreate some of that quality of light, and the patina of age that a vintage print acquires with the passing of time. I begin by introducing a photo of rusted metal, which I adjust using *Threshold*, and then I apply *Gaussian Blur* to soften the shapes. I set this layer to *Multiply* at 33% *Opacity*. Placed over the entire image, this begins to represent "staining" on the picture.

5 There are now five layers: two of textures; two of clouds; plus the background layer containing the mansion itself. Now it's just a question of small adjustments, highlights, and touching up. The main finishing touch is the ground, painted directly on the mansion layer using the *Airbrush* at a very low *Opacity*. Notice how the texture layers above influence this painting underneath.

GOBLINS!

OLIVER HATTON IS A FREELANCE ARTIST, concept artist, 3D modeler, and animator living in the southwest of England. Since entering the games industry as a concept artist in 1995, he has worked on numerous successful titles for various companies, contributing to many ground-breaking video game projects.

Using 3ds Max and Photoshop to create a rickety woodland shack infested with goblin creatures, Oliver demonstrates how to quickly achieve simple yet effective results with some of the basic tools available in 2D and 3D packages. These are also very useful for getting fast results under the pressure of a tight deadline, as he reveals.

"To begin with, a little background story to set the tense scene. The first 'final' render I made for this image took two days to complete! Because at the last moment, as the program was calculating the *Lens Effects* I had painstakingly developed over time, the program then informed me it had run out of memory and would now close. It was just two more days until my deadline, and I only had an unfinished tiny test render to show. Horror!

"To ensure that I would get something on the next render I reduced the render size, turned off the *Lens Effects* and, at the last moment of rendering, paused the program and took full-size screen-grabs of sections of the image and pasted them together in Photoshop. Just in case. However, the render worked fine, and in half the time

too, but now some of the image's elements were missing. I had to turn to Photoshop to finish the image.

"I think that in cases like this, finishing a 3D piece using 2D shortcuts is acceptable, as all the extra effects created in this way could be applied in situations where touching-up is impossible—for example in an animation, using post-production software such as After Effects."

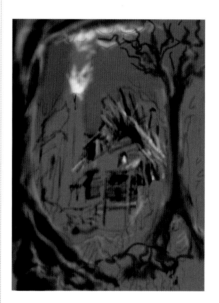

1 I began this image by creating an extremely rough compositional sketch in Photoshop. It's great fun to get a neutral-colored blank page and simply scribble on it with the *Burn* tool and, by clicking the *Alt* key, quickly switch to the *Dodge* tool to create random highlights. I use this technique a lot when working out concepts and am still not sure what I'm aiming for. By varying the size of the brush and the pressure applied, one's imagination begins to pick out almost photorealistic imagery from these blobs of scribbled shapes drawn on "auto pilot." The skill is in "chipping" visual finds out of their scribbled bedrock.

SOFTWARE 3DS MAX, PHOTOSHOP ARTIST OLIVER HATTON WEBSITE WWW.OLDROID.COM EMAIL OLDROID@EMAIL.COM

2 I began the 3D scene by constructing a tree in 3ds Max. Apart from making endless test renders and tweaking the atmospheric effects (which is good fun), this was the most time-consuming part of making this image.

After *Lofting* various adjusted copies of one *Closed Spline* along another vertical line, I had created the trunk so that it had a more organic, variable girth. I converted this to an *Editable Mesh* and began *Extruding* selected edges at the base of the trunk for the beginning of a root "leg." After a certain distance I then split the root by selecting only half of the edges I had previously selected and then *Extruding* those. I then had to build in the missing polygons in the V-shaped gap this created, before continuing to *Extrude* the new root tendril. After doing this, I copied the faces of the root leg, shrank them, and attached them to the smaller end of itself to try to create the dendritic shapes that trees generate.

After doing this once, I copied this root part around the bottom of the tree to create the rest of the roots, modifying it here and there to give it more of a random appearance. At this point, I *Selected* the whole object (including the trunk), *Copied* it, and turned it upside-down to create the canopy. After creating a texture and *Bump Map* in Photoshop, the tree was finally complete.

3 The land was then created using a simple plane with a number of length and width segments. I pushed and pulled this around at *Vertex* level, using *Soft Selection*, limiting the movements to the vertical axis only, until I had roughly recreated the land shape from the concept drawing. The background is a simple plane facing the camera, with a *Bitmap* image applied to it.

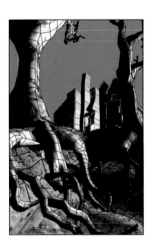

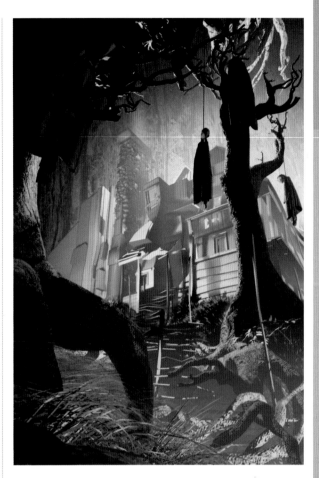

4 The house (or sawmill, as I originally imagined it to be) is made from a collection of modified *Primitive* boxes, which again I modified at *Sub-Object Level*. Primarily, I extruded edges and faces and then pushed and pulled the polygon's surfaces so that they became the sides of the building. The shadows hide the fact that it has the default "Wood" texture from Max's material library applied to it. This would not stand up to any close scrutiny, but that was never its purpose, it just needed a convincing shape to be cloaked in gloom. And so, a couple of hours after starting it (not including minor details like the roof spikes, which I decided to add later), it was finished.

A number of elements in this image simply use modifiers that are provided with 3ds Max 7.5 (or higher). The grass on the landscape surface is one example of this. It is the *Hair and Fur WSM* (*World Space Modifier*), with the size, thickness, and color settings adjusted until it has a more grass-like appearance, which I think it does fairly well. In the *Environment/Effects* panel, I set the hair and fur effect to use the *MR Primitive* setting.

4

⑤ The hanging sack-cloth figures also rely on another Max 7.5 modifier—*Cloth*. Here I positioned a fairly dense plane above a quickly modeled "hanging body shape" in a separate file and applied the *Cloth* modifier to it, then sat back and marveled at the calculating power of computers as the cloth slowly settled onto the body as

Collision Object. I then *Merged* this *Mesh* into the scene and copied it a few times, placing the results in the trees to give the impression the goblins were up to no good. Before the *Cloth* modifier was available in Max, it was still possible, if more time-consuming, to create cloth systems using the *Reactor Cloth* modifier.

⑥ The goblins themselves are, of course, identical copies, *Merged* into the scene again and again until there was a fairly sizable pack of them.

After constructing the goblin, by pushing and pulling a simple *Mesh* developed from a cylinder by *Extruding the* edges, I began the most technical aspect of the scene, which was to *Skin* a *Biped* system to the goblin *Mesh*. The process began simply. I created a *Biped* figure (*Create > Systems*) and scaled and rotated the limbs and spine of the *Biped* until they roughly matched the form of the goblin. I then added a *Skin* modifier

to my *Mesh* and chose all the bones of the *Biped* to be the objects the modifier should use.

Working with light

There are no particular rules for light placement and fog creation etc., as every scene is different. But it's good to try and keep things simple. If some areas seem either too dark or over-lit, I try to look at the overall settings of any lights that may already be in the scene before including any more. It's possible that a better atmosphere can be created by just extending the area of influence of an existing light, rather than by adding extra lights to illuminate a problem area. Although, having said that, there are quite a few lights in this scene, but some of these are set to exclude certain objects so that the scene doesn't get too bright. For example the grass is illuminated with an Omni light set to cast Mental Ray Shadow Maps, which, in my opinion, helps generate the optimum effect the Hair modifier can generate. The scene is therefore rendered with the Mental Ray modifier so that the grass is visible.

⑦ Here the goblin *Mesh* is placed next to the scaled *Biped* figure to show the *Biped* system more clearly. The *Mesh* should be on top of the *Biped*. It is then immediately possible to move the *Biped* skeleton, and see the goblin *Mesh* move its arms along with them. The main complication is that the mesh is

never perfectly aligned with the biped straight away. Therefore there is a period of tweaking the *Envelopes* and *Vertices* that are accessible within *Sub-Object* levels of the modifier in order to properly control how the *Mesh* will deform when the skeleton is adjusted.

8 Above is a "posed" goblin, controlled by the *Biped* system. I then *Merged* the whole system into my scene and arranged the figure so that it seemed to be interacting with the environment.

I would then rename the *Mesh* and *Biped* system, merge in another copy and repeat the process.

The modeling was now predominantly done, and it was time to generate some spooky atmospheric settings using *Fog* from Max's *Environment/Effects* panel and positioning lights in the scene.

9 So, I've included a layered *Fog* that starts at the floor and fades off as it rises, to swirl around under the roots of the trees. Several *Volume Lights*, placed inside and around the building, generate beams of light through the foggy atmosphere in the air. It is the *Fog* that creates the whitish glow in the air, and I still wonder whether it's too much. I think maybe the whole scene could be a little too bright, and could possibly do with more time being spent on the development of a darker feel, but when time is the decision-maker, sometimes you are left with little choice.

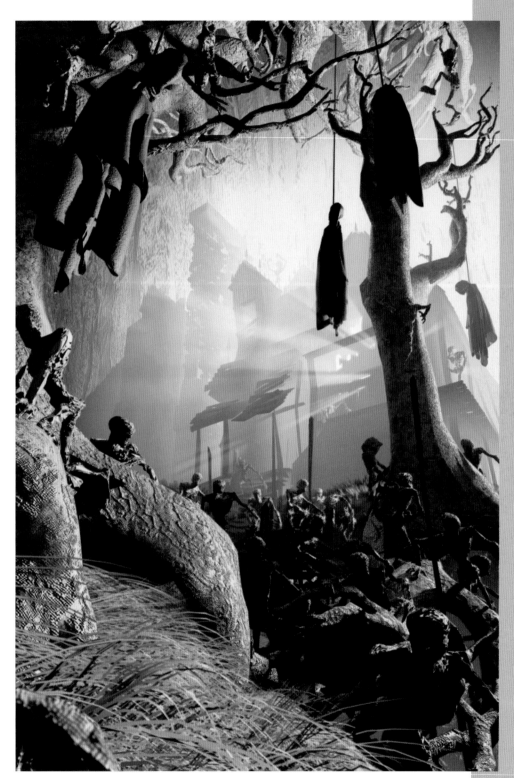

DEMON THRONE

PAUL BOURNE IS A FREELANCE ILLUSTRATOR who has worked with a wide range of clients from many fields, and his background is in traditional painting techniques. Over the last few years he has worked mainly in the games industry, and he is currently lead artist for role-playing games design company Contested Ground Studios. Working with a variety of software, Paul has won numerous awards for his work, including the highly regarded Digital Artworks Excellence Award in 2001.

This tutorial focuses on basic modeling, lighting, and atmospheric techniques. Caligari's Truespace is the software Paul uses for the primary modeling of the background and throne, while the image composition, lighting, atmospherics, and final rendering are all done in Daz's Bryce 5.5. Paul's demonic character is a heavily modified version of Daz's "The Freak" for Poser.

Never surrender

"It may sound obvious, but when learning 3D start off simple, it's easy to be too ambitious and as a result become frustrated. Experiment and get to know the program you're using inside out. The most important thing is to have fun—the vagaries of complex 3D software mean that things won't always go to plan at first, but don't give up. Ultimately it will prove very rewarding."

1 I begin by modeling the armrest of the throne. I open up Truespace and select the *Polygon* tool (circled). First I draw out a basic shape that will act as the armrest's footprint.

2 I click on the *Sweep* tool and sweep out a shape roughly half the height of the depth of the object.

SOFTWARE **TRUESPACE, BRYCE, POSER** ARTIST **PAUL BOURNE** WEBSITE **WWW.CONTESTEDGROUND.CO.UK** EMAIL **PAUL@CONTESTEDGROUND.CO.UK**

3 Using the *Polygon* tool again, I draw out half the shape of the armrest base model using this as a guide.

4 Using the *Lathe* tool, I now carve out a shape that will act as the top of the armrest. I then move the *Lathe* around so that it is aligned along the X axis before setting the *Lathe's* angle to 180°. I increase the number of segments to give the object a smooth, rounded surface, which I do by clicking on one of the *Lathe* nodes and *Dragging*.

5 To model the center section of the armrest, I draw out a shape with the *Polygon* tool again and *Lathe* it along the Y axis. Reducing the number of segments to four, I'm left with a deformed box shape. I now *Copy* this shape down to the base of the shape to act as the armrest foot.

6 At this point it's probably a good idea to give each element a name. This gives me more control over texturing when the final objects are imported into Bryce. I do this by right-clicking on the *Object* tool (the white arrow) and typing in a name for each object in turn. Once this is done I glue each object together using the *Glue as Sibling* tool (circled). Now that the armrest is complete I make a copy of it and place this 1.5 times the armrest's height to the right of the original. Now I can make a start on the throne backrest, seat, and plinth.

4

⑦ For the throne seat I made two copies of the center section of one of the armrests, and scaled them up so that they joined the two armrests together. I squashed down the top section of the seat to be in line with the center of the armrest, while I embellished the center of the bottom section with some scrolling, which was again copied from one of the armrests. As in the previous step I name each object and glue them together using the *Glue as Sibling* tool.

⑨ To finish off the backrest I add a flat plane, using the *Polygon* tool again, to fill in the space made by the backrest border. I copy the armrests and reduce the copies in size by about 50%. (I've also removed the larger skulls and increased the size of the scrolling.) I add these to the backrest about halfway up the sides, and name and *Glue as Sibling* as before.

⑧ I now plan to model the throne's backrest. As in steps 3 and 4 I draw out a shape and *Lathe* it along the X axis. This time I move the center of the *Lathe* so that the drawn shape will reach across the whole width of the throne seat before using it to carve out at 180°. To create the sides of the throne back, I select the *Sweep* tool and click on the two bottom faces of the arc I've just carved out. I then drag these faces out so that they are 1.5 times the height of the armrests.

⑩ I still need to model the plinth, and glue the throne together. I draw out a shape similar to steps with rounded lips and use the *Lathe* over 360° to carve out the circular plinth. I then resize the plinth to make sure that the throne will fit on it comfortably and rename as before. I glue all the pieces of the throne together and rotate it through 90°. Now I save the final throne object as "Throne.cob" for exporting into Bryce later on. Now I can get on with modeling the columns and archways.

(ensuring the column top is almost brought to a point, to accommodate the archways).

The archways are modeled in the same way as the throne backrest. I draw out an upside-down dome shape and lathe it over 90° along the Y axis. If making a symmetrical shape of this kind proves tricky when drawing it out, I'll draw just half the shape, copy it, and glue the two pieces together.

Piecing it all together I *Copy* the arch twice and arrange all three pieces at 90° to each other with the central arch facing left (as shown below). I then arrange each arch on top of the column making sure that each one intersects the column-top relative to the arch adjacent. I now name each model part and glue together.

(11) To model the columns I draw a long rectangular shape with some detailing at either end. I *Lathe* the shape over 360° in the same way as the plinth. Next I *Copy* the column three times and arrange these into a square shape (two rows of two). I model the base and top of the column in the same way as the center section of the throne armrest set out in step 5

(12) I now *Copy* the finished arch section and click the *Mirror* tool to create a mirror image of the original object, positioning the two sections together to form the completed archway.

(14) To set up the document in Bryce 5.5, I go into *Document Setup* and set the document resolution to 400 x 600. I then click on *Constrain Proportions*, so that I can easily scale up the resolution for the final render later on.

To set the ambient light and atmospherics I select a cloudy sky from the *Sky & Fog Presets* menu, before going into the *Sky Lab*. There I set up the *Sun & Moon* section as shown above.

Under the *Cloud Cover* section I clicked on *Spherical Clouds* and *Cast Shadows*. I set up the *Atmosphere* section as follows: *Fog color* as white, *Density* at 0, *Thickness* at 0, *Base Height* at 11, *Haze color* as white, *Density* as 25, *Thickness* as 44, and *Base Height* as 0. I set the *Color Perspective* to 15 for R, G, and B. I clicked on *Blend with Sun* and set both *Color* and *Luminance* to 100%.

(13) Using the *Polygon* tool again I draw out some wall shapes around the arcs. I name everything that hasn't been named already and glue the whole thing together, again using the *Glue as Sibling* tool, saving the finished model as "Archway.cob."

(15) I set up my *Camera* as shown right, please note that these are the settings that I used for my *Camera* set up, but if you can find a better camera angle, use it! With a different camera angle though, it should be remembered that the *Sun* is *Linked to view*, so the *Sun*'s angle may need tweaking to get the desired effect.

(16) Once I had set the intangible elements of the scene, I imported both "Throne.cob" and "Archway.cob." I selected both objects and clicked on *E* in the *Edit* menu, which opens the *Edit Mesh* dialog. I selected 37° and clicked on *Smooth* to smooth off the models when they are rendered, eliminating any sharp edges between polygons.

(17) To apply texture, I selected the throne and clicked on *U* in the *Edit* menu to unglue the model into the separate objects named in Truespace. I deselected all, and then clicked on the part of the throne I wanted to texture first.

(18) In the *Materials Editor* (*Edit > M*) I selected a suitable stone texture. Here I've used a texture from my own materials collection but some of the Bryce default stone textures will work just as well. The screen-grab above shows the values I selected. These seem to work best with imported textures but it is worth experimenting with different *Texture Mapping* modes to see what works best.

(19) Happy that my first object looks suitably stone-like, I continue to texture the rest of the objects. By clicking on the *Transformation Tools* button I can multiply the texture so that it is mapped onto the object any number of times, or rotate the texture to achieve the desired effect. Remember when allocating different textures to keep the ambient color roughly the same for all textures in the scene. That way no objects will stand out unnaturally.

(20) Now that I've textured the models I select all the objects in the archway and group them back together. I duplicate the archway (*Edit > **Duplicate***) and line up the archway copy directly behind the original model to create an arched hallway. I then import my character and position him so he's sitting on the throne. I've used a modified version of "The Freak" exported from Poser as an OBJ file. When importing an OBJ file from something like Poser the textures are already assigned, but remember to change the *Ambience* values in the *Materials Editor* to blend your new object with the rest of the scene.

21 As well as the *Sun* giving some ambient light, there are seven other lights illuminating this scene. Lights 1, 2, and 3 are all circular spotlights with an *Edge Softness* of 20 and a *Brightness* of between 15 and 30. (Light settings can be changed in the *Light Lab*, accessed through the *E* button when a light is selected.) Light 1 is set to illuminate the throne and the character, with Light 2 focusing on the left side of the character's face and shoulders. Light 3 is set above the character pointing down at about 60° to highlight the top of the first archway (the *Edge Softness* of this light source means that illumination has faded to 0 by the time it reaches the bottom of the archway). Lights 4 to 7 are all set the same way. Each is a *Square Spotlight* with the same *Brightness* and *Edge Softness* as before. Each light is centered above an archway and is angled down at around 50°.

22 To finish off the scene I've added some *Volumetric Smoke* a give a bit more atmosphere. To do this I create a *Cylinder Primitive* (I've used two here) and select the *Materials Editor*. I go into the Bryce *Textures* presets and select one of the *Volumetric Smoke* textures. I set the *Texture Mapping* mode to *World space*, *Edge Softness* to 100, and *Fuzzy Factor* to 300. From here I can experiment with the *Base Density* and position of the *Cylinder* in the scene, until I achieve the effect I want.

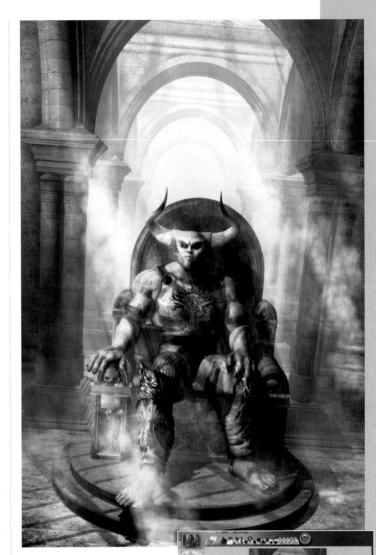

23 Lastly I go back into the *Document Setup* dialog and set the *Document Resolution* to 2000 x 3000 (or indeed whatever final render resolution is desired). I set the render quality I want by clicking on the down arrow next to the large *Render* button (here I've used *Super* but a *Normal* rendering mode would be fine). Remember though, that the higher the render quality the longer the final render will take. And so now, all that's left to do now is to hit that big *Render* button and take a well-earned break.

GHOST SHIP

ANGELO **B**OD **WAS A SENIOR ARTIST** at Sony Computer Entertainment Europe's Cambridge studio (SCEE), where he created this digital model of a ghost ship. Here Angelo reveals work-in-progress Maya screen-grabs, showing the *MediEvil Resurrection* team's development of both the detailed exterior and interior decks of an enormous ghostly galleon. The final version of this can be seen in its full glory in the finished game, complete with effects and characters moving around onboard.

For this reason the creative process used in the making of this piece doesn't result in a single, definable image like others in this book. Instead, it shows the creation of a fully immersive, virtual environment, designed to be an entire level of a computer game. This means that the ghost-ship sequence of the game itself is the final, completed piece of art, and this can be further appreciated by exploration and interaction while playing the adventure.

"*MediEvil Resurrection* is based on the original PlayStation *MediEvil* game, and so we had a strong visual foundation to build from," Angelo explains. "A ghost-ship level appeared in the original, which we wanted to update for the new game, so our team redesigned the flow of the level and its basic plan. A very rough template was prepared, onto which we could start modeling. We began by studying this plan, along with sketches by the lead artist Mitch Phillips. We then started to model the rough geometry, reshaping elements to get an idea of what the main areas would look like."

① Here is how we shaped the rear of the deck and other sections, making sure the polygons were no bigger than 2.5m in size to avoid texture-warping in the final game. We concentrated on the modeling first before merging any *Vertexes*, adding *Edge Smoothing*, *Vertex Coloring*, and *UV Layout*. This way we could quickly build the level for play-testing purposes, and also get a feel for the whole level's shape.

SOFTWARE MAYA, PHOTOSHOP ARTIST ANGELO BOD ART DIRECTION MITCH PHILLIPS GAME STORY AND CONCEPT CHRIS SORRELL
PRODUCER PIERS JACKSON WEBSITE WWW.MEDIEVILRESURRECTION.COM

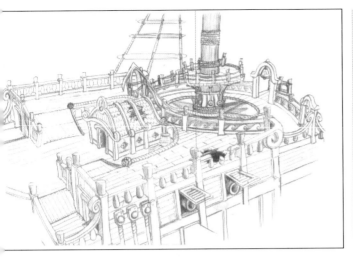

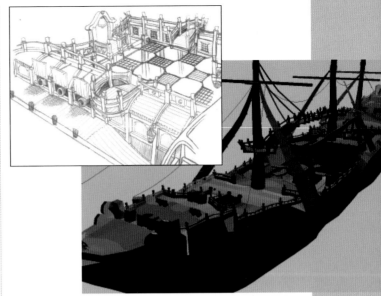

3 Now most of the details had been constructed, although the ship was not yet ready for export to the game. We had to check everything against all the level design's strict guidelines, such as the width of corridors, the ceiling's height, the maximum incline of steps, as well as corners that had to be a certain minimum angle to avoid in-game characters getting stuck. So, not only did the model have to look good and be correct graphically, but more importantly it had to play well once imported into the game. Quite a few adjustments had to be made on the ship, to allow for this and to ensure everything was free of bugs.

2 Further detail was added, as we worked closely from the concept design sketches. We included some *Fog* effects and placed some lights to create a little atmosphere while we worked on the ship. Monotone colors with ambient light are good for checking shapes and contours.

Sea devils

Draw inspiration from the archetypes of horror, without descending into outright cliché. The sea provides a wealth of deliciously spooky imagery, ghostly tales being synonymous with the history of pirate galleons, isolated lighthouses, and weird monsters from the deep, providing a terrific source for potent horror visuals set in any period.

4 This is a shot of one side of the ship, showing the application of some *UV Maps*, using the first set of basic textures we created. Edges have all been rendered *Hard* and *Soft*, and it has not been *Vertex lit* yet, this is just the same ambient light we used earlier. Laying out *UVs* for such a big object is quite a task, but luckily there was sufficient time in our schedule. We had sixty working days to complete all work on this monster ship, to make it fully playable, lit, and bug-free.

5 This is a small compilation of the ghost ship's comprehensive texture sets. The painted textures were created in 512 x 512 pixel format, so we could put a fair amount of detail into them.

When converting them back to a smaller size the details would still be visible, although all textures were ultimately converted to a 4-bit palette (16 colors), and some textures carried an extra *Alpha Channel* for transparency.

7 This is a side shot of the ship, complete with its lower deck inside. Most of the modeling of the exterior was now done. The following steps show some images of the ship's interior environments. The model is very long and looks out of proportion, but this is all due to the game-play template. As this model is designed to be an entire in-game level, the most important goal is that the level is fun to play.

6 This shows progress made on the ship's exterior, with 95% of all texture work completed. Working all the way from the back to the front of the ship, we use the same processes, modeling, cleaning geometry by merging *Vertexes*, adding *Soft* and *Hard* edges, laying out the *UV Maps*, and applying the painted textures.

8 This interior shot from below decks in the ghost ship shows all the textures that have been applied, and some of the light effects on the floor.

10 This is the corridor from the lower deck leading to the "Boiler Guard" room. Doorways are all blocked with these metal gates, and the player has to trigger switches to get through. Again, flickering torches and lights are placed within the game map later.

9 This is the cabin where, when you play the game, you'll find some of the evil "Boiler Guard" characters. What you're not seeing here are the torches and their effects, as they are placed within the game map itself and therefore will not show in this Maya screen-grab. The characters do make the level come alive, but on the other hand, this deserted state suggests a ghost ship just like the Mary Celeste.

11 This view is looking through the gate between the big lower deck and the "Boiler Guard" room, where the player gains access to the spooky lower decks.

THE NIGHT GALLERY

THE WORLD IS FALLING APART

"The architecture is based on reference photos I took in Italy, and its collapse is intended to represent chaos when the end of the world is nigh."

ARTIST **TORSTEIN NORDSTRAND** SOFTWARE **PHOTOSHOP**

DEMON CATHEDRAL

Photographic elements have been combined by Dave to create this towering Gothic ruin, reaching up toward the full moon in a Bryce-rendered sky. 3ds Max was used to create the snaking, segmented body of the winged horror rearing above.

ARTIST **DAVE CARSON** SOFTWARE **BRYCE, PHOTOSHOP, 3DS MAX**

CHAPEL

Grzegorz's landscapes are on a biblical scale. Here the title "Chapel" belies the extraordinary structure dominating this scene. The sky behind is suffused with light, channeling the power from the heavens, connecting the edifice to a greater being—an effect also present in the greatest examples of medieval Gothic architecture.

ARTIST **GRZEGORZ KMIN**
SOFTWARE **PHOTOSHOP**

SILENT LURKER

"Old dilapidated buildings inspired this particular
background and setting. While viewing the space,
I imagined that something lived there, only appearing
at night to creep about in the filthy gloom."

ARTIST JASON FELIX SOFTWARE PHOTOSHOP

UNDEAD

The sun has hit the rim of the world and caused the veins of night to bleed, and within the mausoleum the light returns to the vampire's eyes. The classical statues in this scene appear to be angels, but for all their divine association they stand guard only impotently over the dreadful waking form.

ARTIST DAVE CARSON
SOFTWARE PHOTOSHOP

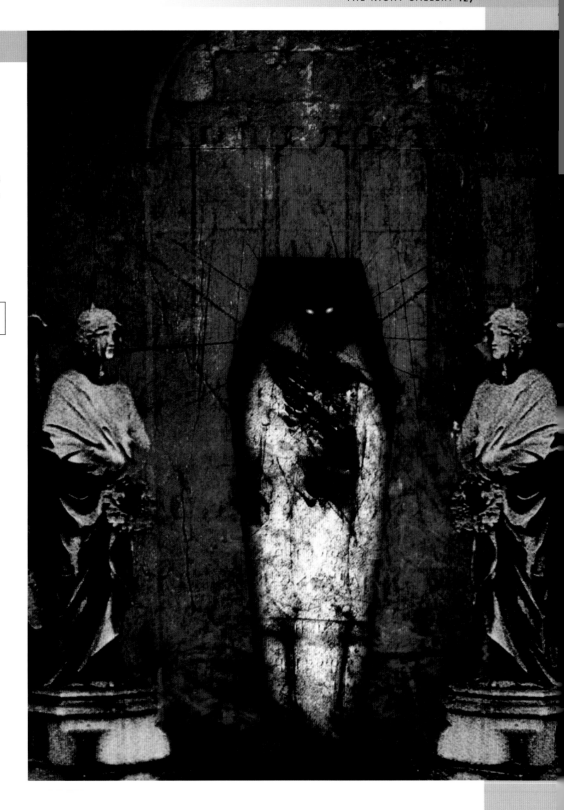

SUNRISE OVER CALCULUS TOR

"This artwork was originally produced for the role-playing game *A |State*. Both the modeling and rendering were created in Bryce using terrain maps for the buildings as well as the spires and the mountain range."

ARTIST PAUL BOURNE SOFTWARE BRYCE, PHOTOSHOP

VISITATION

Recalling the spectral appearances in the superb Nigel Kneale television adaptation of Susan Hill's book *The Woman In Black*, this scene captures all the haunting chill of a classic Victorian ghost story. As Tony reveals, "I especially love ghost stories, and wanted to try my hand at something a little thought-provoking in that area. Grain and noise were added for effect during post-work in Photoshop."

ARTIST TONY HAYES SOFTWARE VUE, POSER, PHOTOSHOP

4

House of the Dead

Reminiscent of scenes from one of George A. Romero's *Living Dead* movies, any of the many Italian zombie movies of the '70s and '80s, or computer games such as *Resident Evil*, the zombies advance in their inexorable pursuit of human flesh, and the SWAT team-member doesn't stand a chance.

The black-and-white image shows an early stage in the creation of the main image. This monochrome painting, after more detail (and the SWAT officer) have been added, will form the basis for the color to be introduced using semi-opaque *Brush* modes and layer *Blending modes*. A texture pattern has been incorporated to create the wallpaper design by using a layer *Blending mode*, and at this stage it hasn't yet been erased from the window areas.

ARTIST **MATTHEW BRADBURY** SOFTWARE **PHOTOSHOP**

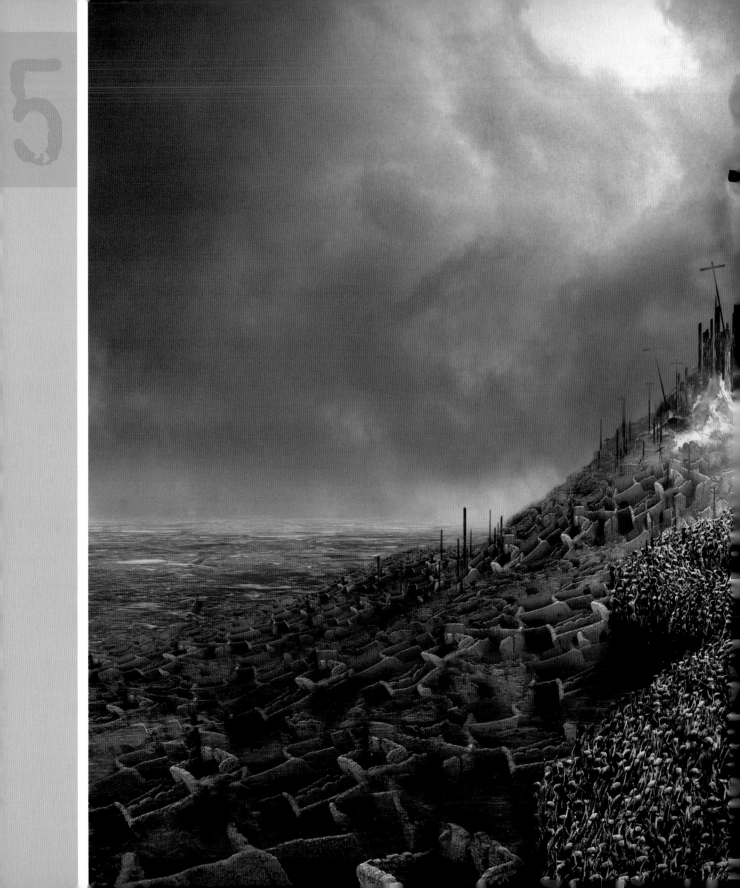

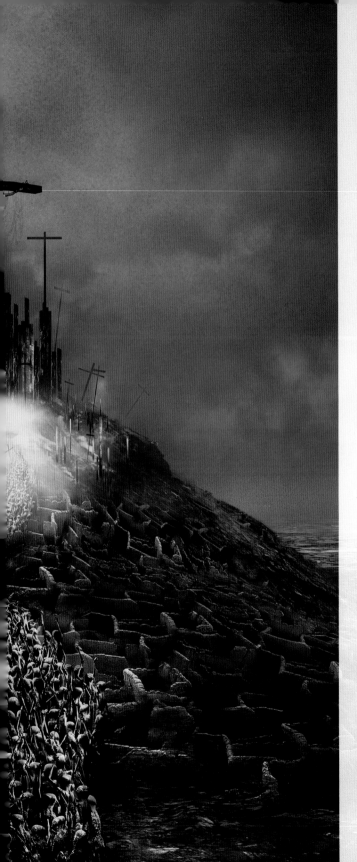

THE HAUNTED REALM

Embark on a fearful journey through the dark and eerie landscapes of the imagination —moonlit forests and haunted woods, mountains of madness, Gothic graveyards, and lightning-struck chiaroscuro ruins. In this section we explore environments that provide evocative settings for horror scenes, as well as visuals that are more than mere backdrops, being immersive and atmospheric landscape paintings in their own right.

INFESTED FOREST

Leo Hartas is a well-known and highly regarded illustrator, skilled in both traditional and computer-generated techniques. He is the author of several books about computer game art and cartoon art, and has illustrated numerous bestselling children's titles. Leo also creates digital imagery for computer games, video animation, and television series.

Here Leo demonstrates his painting methods, using Photoshop's basic paint tools over the solid foundation of a well-structured sketch. He says of his approach to digital painting: "Like a lot of artists working digitally, especially those coming from a traditional background, I find I only use a small percentage of the tools and techniques available within a package such as Photoshop, so I keep it simple. It's like a well-stocked art shop, full of exciting and expensive equipment, but all I really need to go in for are a couple of decent brushes."

Back up! Back up! Back up!

The importance of frequent and regular saving of your painting while you work cannot be stressed enough. The very worst disaster that can befall the digital artist is to lose work because of a crash or some other unexpected computer error. Make saving an obsessive habit, as it can avoid a great deal of frustration and heartache. Save separate stage files of an image as you progress, and multiple copies of a final image on more than one disc.

① I started with a few thumbnail sketches to sort through my initial ideas and basic compositions. The problem is they are so vague that if I glance away for a moment, I look back to find an unintelligible scribble. I was looking for a dream landscape, somewhere so vast and gloomy that anyone finding themselves there could only hope to wake up.

From there I looked to the hedgerows and banks that line local walks for inspiration, where complete miniature fantasy worlds of mossy forests with cathedrals of twisted roots exist. With an idea forming I went on to a larger drawing on tabloid-size paper, which neatly fits my scanner. I purposefully kept the drawing rough as I wanted to "find" the details of the landscape during painting.

SOFTWARE **PHOTOSHOP** ARTIST **LEO HARTAS** WEBSITE WWW.LEOHARTAS.COM EMAIL LEO@LEOHARTAS.COM

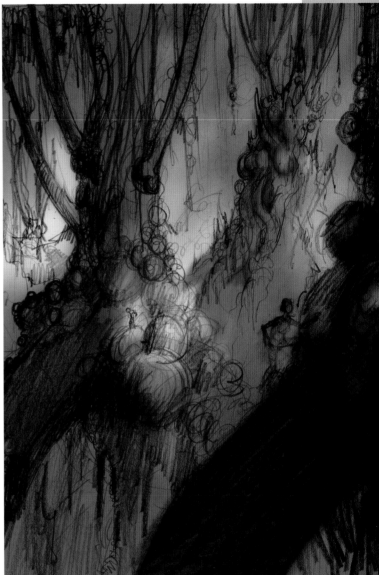

(2) The composition is from a classic method of creating space by repeating dominant shapes, similar to telegraph poles, receding into the distance. I scanned the sketch into Photoshop and set up my standard starting layers: a white background on the bottom, followed by a base paint player, with the scan above set to *Multiply*. If I'm feeling particularly organized I name them: "Background," "Paint," and "Line." Though I preach organization, as my work progresses I find myself rifling through a stack of unnamed layers set to all kinds of *Blend* properties—if I worked in real paint I fear my studio would be a tumbling mess of tubes, spilled paint, and teetering piles of books and drawings. The final preparation is to increase the *Brightness* and *Contrast* of the scanned drawing, turning gray pencil into black line.

(3) Using a big soft *Paintbrush* I block in the background colors and main shades in the Paint layer, effectively painting with transparent inks. Like most artists, I follow a process of working "wide and rough," then through a series of passes I'll tighten up the detail. At this point I quite like it as it is, and consider proclaiming it finished and taking the day off. It seems a shame to paint over the vigorous pencil lines and wonderful graininess of smudged graphite. I finally carry on by merging all the layers in preparation for the next stage.

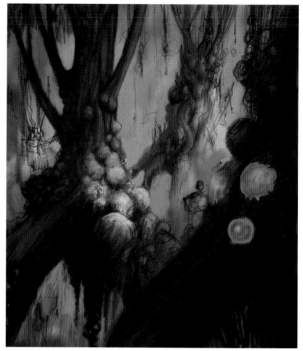

4 Now for the painting proper. I place a new top layer set to *Normal* and set up my favorite *Paintbrush*—the default *Spatter* with *Other Dynamics* switched on. This *Brush*, combined with a pressure-sensitive pen, gives a nice, slightly painterly stroke and with *Shape Dynamics* on it gives extra control for when I paint small details. Now I *Zoom* in, and start working on a region. Using the *Eye Dropper* tool I pick up colors from the *Merged* previous layers and start to paint over them on the new opaque layer. I find this stage the most nervewracking, as

the picture as a whole starts to lose any balance it had, and the quantity of grunt painting work ahead starts to become apparent, if that balance is to be regained.

But it's also an exciting period of experimentation on the image—in trying to find a final look that will work across the whole painting. Working digitally can help a lot with experimentation, as you can *Undo*, although I've always experimented directly when using traditional media, even at the risk of trashing the whole image. Perhaps it's a desire for thrills—illustration on the edge!

5 I have an idea that the circular forms could contain monsters waiting to burst out at any moment—it would give the landscape an extra brooding tension. Using a rather too bright orange I messily paint them in and start to worry as the whole painting looks hopeless.

6 This step represents a three-hour jump forward. I've continued to paint by tightening up detail on all three trees simply by using tones picked from the existing work using the *Eyedropper*. I've added another layer on top, set to *Darken*, where I used a large *Brush* to make broad changes in tone, such as knocking back the bright orange forms. Throughout this stage I flit about the painting, tackling tough areas then resting by working on

However, there are a couple of successes; one being the overall composition, which still holds, and the other, an emerging style on the middle-distance tree that has nicely combined the grainy pencil with rough surface paint.

areas where I have a clear notion of how they should be handled.

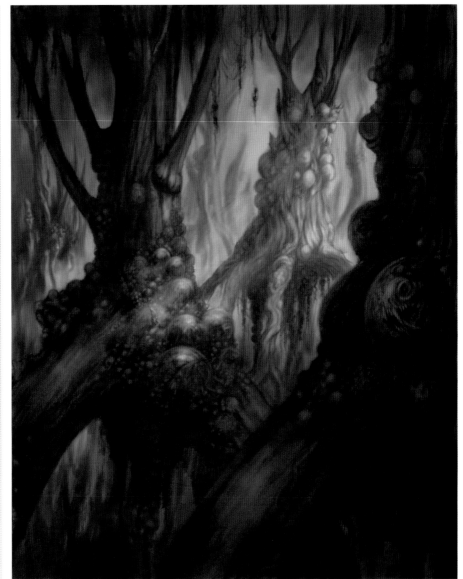

(7) I painted the monsters in the domes on a new layer set to *Multiply*, using a simple monotone. When combined with the rough orange I'd painted earlier they looked three-dimensional and suitably slimy in their alien amniotic fluid. Over the years I've found painting from the imagination requires a library of effects and tricks, picked up by experimental accidents, observation of the real world and studying the work of others.

(8) The final stage is always the most enjoyable phase of a painting, where the heavy work is complete and all that remains are the finishing touches. Some of these can be quite radical, such as fairly broad deepening of tones and lighting using new *Darken* and *Lighten* layers. I put a final layer on top of all of this for highlights. It's an opaque layer where I pick out the figure in the middle ground with subtle shafts of light, and polish the domes with a slight gleam.

It's worth pointing out a simple paint technique that I use exclusively with digital, which is to lay more paint down than required and then use the *Eraser* to shape it. It seems obvious, but I think it helps to avoid the problem that digital paint strokes all have the same quality, unlike real paint where accident gives them character. I used it particularly to adjust the delicate shaft of light, and to blend the highlights into the surface.

GOTHIC CITY

IN THE SECOND OF HIS DEMONSTRATIONS using Photoshop, Robh Ruppel outlines his approach to creating a dynamic composition, and shows how the incorporation of photographic textures can enhance the architectural details of this Gothic metropolis.

Working in illustration, model building, production design, and art direction has given Robh experience of a wide variety of media and he is very aware of how blurred the dividing lines between them have now become. Robh sees the digital painting process as having moved much closer to that of photography because images can be changed and manipulated, leading to both skills often having similar goals.

"The most important advice I can offer to anyone, working in any medium, is the understanding of form and how it relates to perspective. The ability to break an object down into light, shadow, and halftone is very important to keeping the delineation of form true and solid. I've discovered that the consistent themes in my work are light, composition, and shape. I love light as an energy: the different kinds of light and how its different qualities manipulate the emotions. All these factors come into play when making an image. A painting is about what you WANT to say, not necessarily about the cold facts in front of you. A good painter will rearrange the elements to make the picture interesting.

"When it comes to painting digitally, the only disadvantage I see is that no one-of-a-kind original results. Everything else, at least for commercial purposes, is much better than working with traditional tools. The ability to subtly adjust values and form without ruining the piece is invaluable, and layers are wonderful!

"My horror artwork is inspired mostly by literature. The mood that H.P Lovecraft created in his writings has never been equalled in my opinion, and I try to visually parallel how his writing affects me. His work is so utterly creepy without being overtly gory. Poe is pretty good too!"

SOFTWARE **PHOTOSHOP** ARTIST **ROBH RUPPEL** WEBSITE **WWW.ROBHRUPPEL.COM** EMAIL **RUPPEL@EARTHLINK.NET**

2 The second most important part, after having an idea, is composition. You must have an interesting division of space and value. So many times you see images where the artist started adding detail without thinking about the overall arrangement. I always strive for an unequal division of space and value when setting out to design an image. It's easy to get too repetitive in shapes and masses, thus making the design static. I worked up several rough value ideas till I got one that seemed to have a nice dynamic to it. Once that is established you've laid an excellent foundation for the rest of the picture.

3 Since my final goal was to be realistic in execution, I started with a sky photo for the base background. I then started roughing in my major shapes, values, and colors to get the spirit of my composition while allowing for a chance to better it as I explore. Everything is kept very loose at this stage so I can judge the abstract qualities of the art as I go. Does it recede in space? Are the shapes interesting? Is the composition dynamic? These are the questions I ask myself when I paint. I then establish my perspective and eye-line. I like to do this after moving shapes around because it allows greater freedom in the arrangement. By "retro" engineering this into the picture I have more freedom to design and alter. Too many times artists start with a grid and then allow themselves to be constrained by it completely.

1 The most important part of the process is to have an idea, a concept. With this image I was thinking about opposites. I was tired of seeing bland mega cities that all have a similar idea, so I thought about giant Gothic cathedrals as a departure. What if a technological advance had occurred somewhere in the Middle Ages that allowed exponential growth, but stylistically the buildings retained the esthetics of the Gothic style?

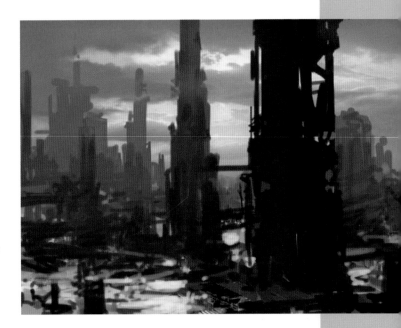

Studying form

Working in any medium, the understanding of form and how it relates to perspective is vitally important. The ability to break an object down to light, shadow, and half tone is crucial to keeping the delineation of form true and solid.

④ Once the perspective is working I'll lay in some photos to get a bit of texture to the piece right away. Keep in mind that this is only an enhancement. Don't rely on using photos to do the work for you, as it shows—I don't know how many pieces I've seen where a bunch of images have been cobbled together and called a finished picture; it's not; it looks like what it is. I am merely using these textures as a quick way to establish my goal, which is to create a painting of an idea. It all starts with the idea.

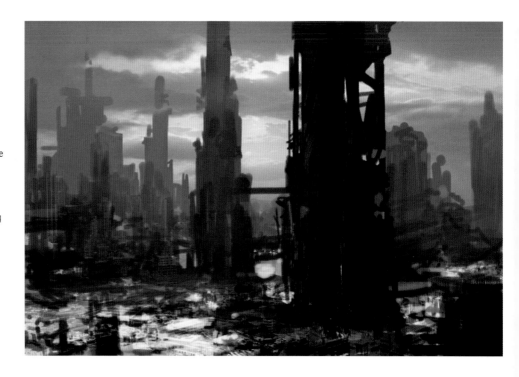

⑤ Now, with a good base of composition, texture, and space established, I can start the finishing or detailing process. None of this would work if I didn't have a strong foundation to build upon, and none of this would work if the shapes and values weren't convincing at an early stage—I can't stress this enough!

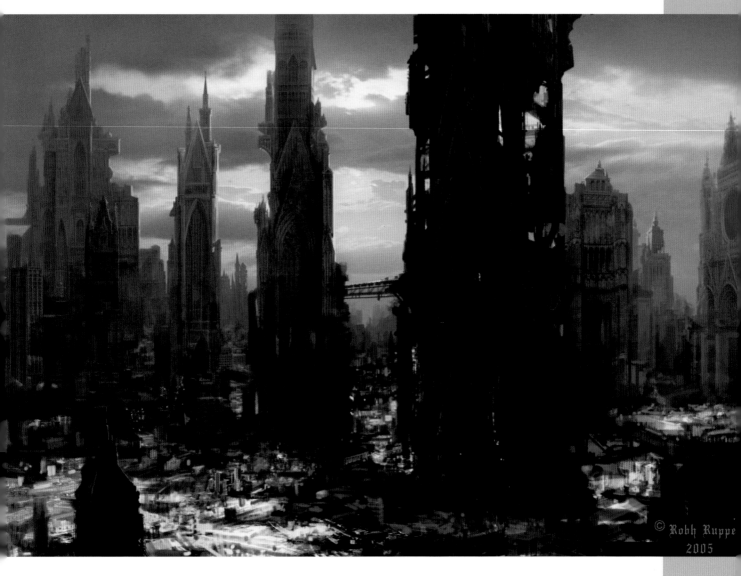

© Robh Ruppe
2005

(6) The detailing is the slowest part of the process as you have to make it work in the range of values you've laid out. I carefully refine shapes and add detail to the painting in order to enhance the idea I am striving for. At this point it's a matter of dozens of layers and carefully adjusting the balance of detail versus space. Ultimately it is the sense of space that I am painting and not a shopping list of mere detail. It all has to be subordinate to the main idea. I carefully check the shapes against my perspective grid as well. Everything needs to follow the multiple vanishing points I've set up.

There is no one technique or *Brush* for this part. I may rough in the design of something and then do the detailed work flat on another layer so I can tip it in using the *Transform > Perspective*, I might also haze back some bit of detail use the *Airbrush* tool to make it sit in space better.

There is an old painting adage, "Start with a broom and end with a needle." I use this thinking when working digitally as well. I start with the broad, large masses and refine them as I go, adjusting the perspective, design, and value till I get to the point where I can't see anything left to "fix."

RAKE MINE

IN OLIVER HATTON'S SECOND 3D TUTORIAL, he focuses on the modeling of simple, yet very effective rock faces, which are a major element in the construction of this creepy backwoods chasm.

"The idea for this scene has been at the back of my mind for many years since stumbling across a place like this in a stretch of woods in the Derbyshire Dales. It was an old lead 'rake,' or fissure mine, left to rot for many decades. It was so long and deep it seemed to generate its own weather system, and in its cathedral-like scale and silence, it was awe-inspiring.

"The scene has been built with animation in mind, thus many aspects that I would normally like to see, like complex shadows, have been replaced with a radiosity solution to allow for a quicker rendering rate. The scene renders at just a few minutes per frame. Aside from the *Hair* and *Fur* effects applied to create the greenery, and some basic geometric wood structures, all the scene consists of are rock faces. It's not overtly horror, but there is a nice atmosphere of a rotten, spooky sub-world, where malicious hidden residents skulking in the shadows would be happy to help you fall into the abyss."

Dark places
Visiting an inspiring location can form the basis for a powerful fantasy landscape, distorting or exaggerating what we've seen or photographed. Practice creating features in a scene so that they form a natural and believable part of the landscape's geography. Rocks, for example, need to look like they have weight and permanence, and should appear heavily weathered.

(1) After completing a rough concept sketch in Photoshop, I get down to work in 3ds Max. The rock face in this image starts with a plane that stands vertically, with 15-20 width and height segments. I begin by shifting the segment lines into a more randomly organized pattern, so that the grid this creates is not so uniform, but more like the irregularly layered appearance a faulted rock face possesses. After doing this I begin selecting faces on the plane that I imagine should jut out of the rock wall, and then *Extrude* them.

SOFTWARE 3DS MAX, PHOTOSHOP ARTIST OLIVER HATTON
WEBSITE WWW.OLDROID.COM EMAIL OLDROID@EMAIL.COM

2 With *Soft Selection* set to varying strengths, I move selections of the plane's *Vertices* (in vertical or horizontal strips) in or out to give the surface a more random, and towering, appearance. I then copy this wall a few times to extend the length and depth of the surface, and *Snap* any loose vertices together to get a continuous rock surface.

3 The rock texture is based on a photograph I took while out walking. I love exploring cliffs and quarries, and a digital camera is a fantastic tool for collecting incredible amounts of visual reference.

After adjusting the image in Photoshop to make the texture loop both vertically and horizontally, and perhaps removing any pieces of the image that would stand out in a repeating texture, I apply the map as part of a *Blend* material to the surface, with the help of the *Material Editor*. The other part of the *Blend* material is a moss-like looping texture created in Photoshop. It's possible then to develop an even more random-looking rock surface by using a *Noise* map as a mask to blend the two textures together.

4 Next I give the surface a *Mesh Smooth* modifier, followed by a *Melt* modifier to give it a softer, more eroded feel. I *Copy* this cliff face, *Rotate* it, and then jostle it into position to create the opposing wall. At this point it starts to develop the claustrophobic feeling I'm looking for. The floor of the chasm is a flat plane with a *Raytrace* material applied to it to simulate a water surface deep in the bowels of the mine.

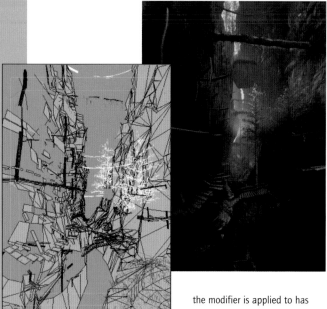

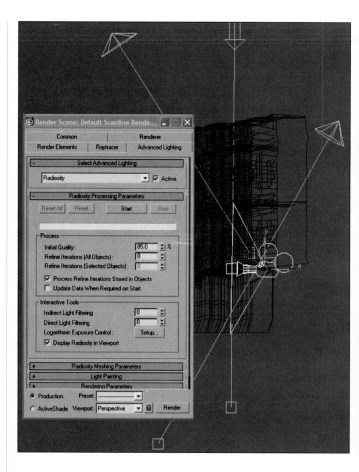

5 I create the grass and foliage using the *Hair and Fur* modifier in 3ds Max. I prefer not to apply this directly to the existing geometry in the scene for several reasons; the main one being that Max can often crash if the surface that the modifier is applied to has over 10,000 faces. What I prefer to do is create lower polygon versions of the objects to which I want to add *Hair* or *Fur*, and apply the modifier to these, and then un-check the *Renderable* box in the object's properties. The *Hair and Fur* modifier is still visible to the camera even though the object is not.

6 Two of the three lights in the scene (above and behind the camera) are there to give a better general ambience, simulating the light cascading down the chasm. The main key light shines from high up in front of the *Camera*, down directly toward the viewer. After setting these up I then let Max calculate the *Radiosity* solution for the scene. Once this is done, rendering times are shortened dramatically as light and shade is "baked" directly onto the geometry.

The *Displace* modifier
Create rocks simply by using a Displace modifier, although bear in mind that this polygon-intensive method does lead to higher rendering times. Take a digital photograph of a cliff face, make it grayscale and increase its contrast. Then apply a Displace modifier to a dense polygonal mesh and apply the new texture as the displacement map. Crank up the effect's strength and watch as the rock shapes push themselves out of the surface. You can then use the original photograph as the rock texture.

7 As a finishing touch, I added two sets of *Atmospheric Effects Fog*; one standard and one layered, and both fairly faint, to create the damp, water-saturated air in the scene.

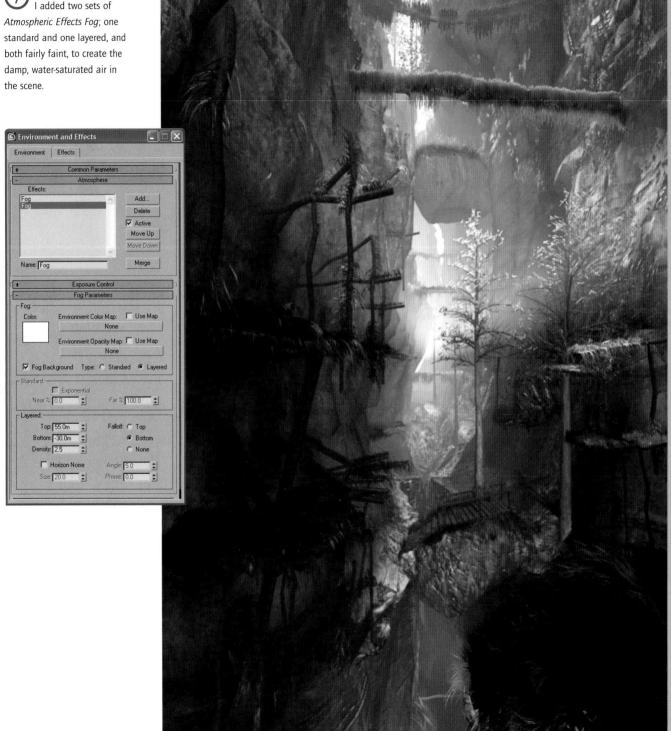

STONE BASTION

PAUL BOURNE'S SECOND TUTORIAL is an introduction to basic landscape generation and atmospheric techniques in Bryce 5.5. The walk-through concentrates on creating a barren, chilling landscape with a heavy atmosphere using a pre-modeled structure, created in Truespace, as the focal point.

"Start off simple," is Paul's advice. "Experiment and get to know the program you are using inside out. I think the most important thing is to persevere. Don't become despondent if things don't work out the first time around—keep going and have fun."

1 I open up Bryce 5.5, go into *Document Setup*, and set the document resolution to *840 x 500* (*Document Aspect Ratio* 1.68:1). I click on *Constrain Proportions* so I can easily scale up the resolution for the final render later on.

2 Setting *Sunlight and Atmospherics* first, I select a cloudy sky from the *Sky & Fog Presets* menu, and then go into the *Sky Lab*. I set up the *Sun & Moon* section as shown in the screen-grab to the right. Under the *Cloud Cover* section I set *Cloud Cover* to 37 and *Cloud Height* to 100. Then I set up the *Atmosphere* section as follows: *Fog color* as white, *Density* at 6, *Thickness* at 57, *Base Height* at 4, *Haze color* as white, *Density* at 30, *Thickness* at 50, and *Base Height* at 0.

I deselect the *Set the Color Perspective* button to revert to the default setting, and click on *Blend with Sun* to set both *Color* and *Luminance* to 100%.

3 I select the *Director's Camera* and double-click on the *Field of View* button, setting up the *Camera* as shown in the dialog above. These settings will give me a nice long perspective shot over the water plane.

The inner landscape
Isolation and brooding menace can be conjured by using dramatic skies and atmospheric weather effects. These can go a long way in conveying many the most fundamental aspects of the horror genre.

SOFTWARE **BRYCE, TRUESPACE** ARTIST **PAUL BOURNE** WEB SITE **WWW.CONTESTEDGROUND.CO.UK**
EMAIL **PAUL@CONTESTEDGROUND.CO.UK**

4 I work on the water next. By default, Bryce creates a ground plane when opening a new document. I *Select* this plane and click on the *Materials* button (circled in red) to go into the *Materials Editor*.

6 Turning my attention to the foreground I click on the *Create* section and select *Create Terrain*. A default terrain will appear in the middle of the screen. I now need to sculpt this so I click on *Edit Menu > E (Edit Object)* to go into the *Terrain Editor*.

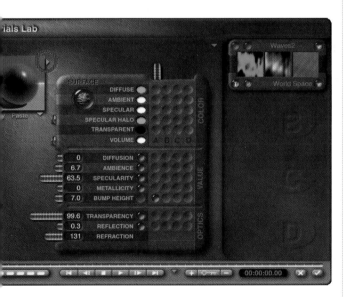

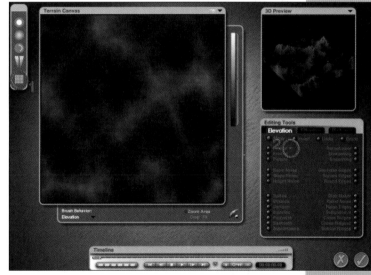

5 Clicking on *Materials Lab* I go into the *Waters* Library sub-section. Under the *Calm* section I select the *Deep Sea* material. Even though this is a good texture, for this image it needs a bit of tweaking, so I change the *Ambient Color* to white and the *Ambient Value* to 6.7. This will help the water to blend into the rock formations and the low-lying fog.

7 The initial default terrain will be relatively low resolution. This is fine for distant objects, but since this terrain will sit close to the camera I need to increase the resolution somewhat. To do this I click on the *Terrain Resolution* button (1) and select either *1024* (massive res) or *2048* (gigantic res). I click on the *Fractal* down arrow (2) and select *Mordor* from the list, clicking on *Fractal* to generate the terrain. Keeping in mind that Bryce generates the fractals randomly, if I'm not happy with the initial terrain generated, I keep clicking until I get something I like.

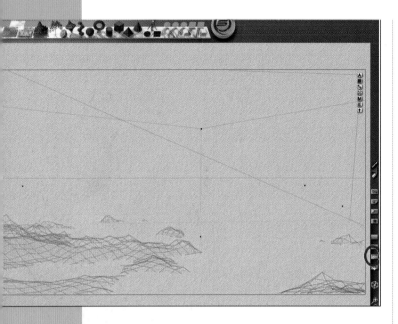

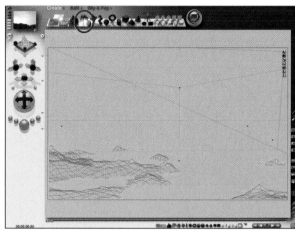

8 I now move the terrain to the foreground of the image, and re-size it so that the edges are outside the *Camera*'s field of vision. I move the terrain down so that only small outcroppings are visible above the water line. To make this easier I click on the *Underground On/Off* button (circled), which renders any part of an object under the waterline invisible.

10 To give the foreground a bit more interest I've added some dead trees, half submerged in the water. To do this I go into the Bryce's *Tree Lab*, click on the *Create* section and then select *Create Tree*. A default tree will now appear in the middle of the screen. Clicking on *Edit Menu > E* takes me into the *Tree Lab*.

9 To texture the terrain I enter the *Materials Lab* again as in step 5. From there I go into the *Terrains* texture library, and under the *Rocky* section I select the *CristalRock120* material. As with the water texture, this one needs a bit of adjustment and I change the *Values* section as shown in the above screen-grab.

11 Under *Shape* I select *Hemlock* from the drop-down menu. By changing the *Gravity* value to 93, and the *Randomness* value to 100, the tree acquires a nice withered shape. I set the *Number of Leaves* value to 0 in *Foliage*. Selecting *Material* under *Texture* in *Branch/* *Trunk* and then clicking on the *Edit* button takes me back to the *Materials Editor* as in step 5. I click on the *Materials Lab* button and go into the *Vegetation* Library. Under *Trunks* I select *Common Ash* and change the material's *Ambient* value to 28.

12 I partially submerge the tree below the waterline so that the majority of the trunk is hidden, and move it to the left-hand side of the foreground between the protruding sections of the terrain.

13 I *Copy* the dead tree a few times, changing the *Gravity* and *Randomness* settings for each one in the *Tree Lab*. Here I've used four trees in total, each with slightly different tree-shape settings, experimenting with different positions and rotations for each tree until I get something I'm happy with.

14 To add the middle-ground, I copy the foreground terrain and rotate it through 180° along the Y axis. I then move this terrain back until the atmosphere starts to fade out the terrain's texture (this may require a bit of trial and error and quite a few test renders). As with the foreground terrain I re-size it so that the edges of the terrain are outside the *Camera*'s field of vision, and I then move it up so that more of the terrain is visible above the waterline. I add a second terrain as in step 6 (this one needs to be a more mountainous shape) and move it so that it intersects the first middle-ground terrain. This will be a good land mass for the building to come.

(15) For the focal point of this image I'm using a Gothic-style temple modeled in Truespace. I import the object (*File > Import Object*) and texture it as in steps 4 and 5. For this I've used textures from my personal collection but Bryce has some great stone texture presets that would do just as well. I position the structure so that it's "built" on the middle-ground terrain. Note that the structure is quite small to give a greater sense of distance.

(16) Even though the sunlight is enough for the landscape, the building needs a bit of extra lighting to pick it out from the background. I select *Create*

Spotlight (1) and *Aim* the spotlight (2) at the structure. To set the light values I access the *Light Lab* by clicking on *Edit Menu > E*.

(17) In the *Light Lab* I change the *Intensity* value to 50 and the *Edge Softness* value to 22. Because this light is only augmenting the sunlight, I keep all the other values at their default setting.

(18) For the background I create two further terrains in the same way as I created the middle ground, and position them at the back of the scene. Because these will be mostly obscured by the atmospheric haze I can reduce their resolution in the *Terrain Editor*. Making both of these terrains quite large will, again, emphasize the sense of distance The depth of field in the set-up of this image is quite long, so if you *Copy* an object and move it toward the back of the scene it looks microscopic. With Bryce, if you make objects toward the back of the scene large, the lighting and atmosphere interact with them differently, giving you a greater sense of scale.

(19) I finally set *Full Resolution* and *Final Rendering* by going back into the *Document Setup* dialog and setting the *Document Resolution* to 2500 x 1488 (or indeed whatever final render resolution I need). I set whatever render quality I want by clicking on the down arrow next to the large *Render* button. Here I've used *Super* with 36 *Rays per Pixel*, but *Normal* render mode would be fine for most purposes.

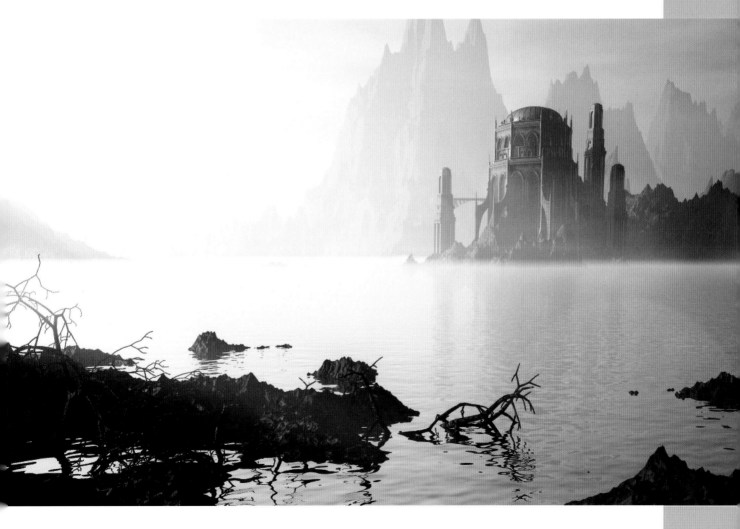

THE NIGHT GALLERY

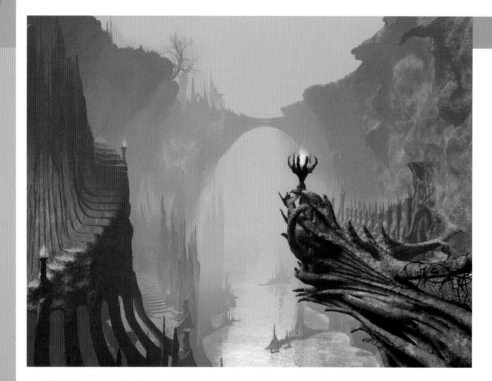

EVIL RIVER

Ivan's aim was to conjure a mood of evil using landscape alone, finding inspiration in Tolkien's descriptions of Mordor in *The Lord of the Rings*, and combining this with his love of Gothic horror. As Ivan reveals: "Everything was modeled from scratch in 3ds Max and rendered with its default scan-line renderer, with just a little bit of post-production work in Photoshop."

ARTIST IVAN KRALJEVIC
SOFTWARE 3DS MAX,
PHOTOSHOP

NIGHT TERRORS

"This is a work-in-progress image, that turned out to be more interesting than the finished piece. This was used as a card illustration and the minimal print size presents many obvious challenges. I wanted something subtle and abstract, but with a clear focus. It needed to catch the eye immediately, hence the moon, with the dimmer details then 'revealing' themselves to the viewer."

ARTIST SAMUEL ARAYA SOFTWARE PHOTOSHOP
COPYRIGHT © FANTASY FLIGHT GAMES

WARNING SIGN

Exploring deep into the darkest reaches of a forbidding jungle, foolhardy adventurers stumble across unnerving signs of hostile locals. Simon's use of light in this scene is particularly impressive, as he shows it filtering down past the stunted jungle trees, to be picked up on the foreground foliage and the waterfall in the middle-distance, he also uses it effectively to draw attention to the figures. Simon explains further: "This picture was a result of me wanting to paint something that was faintly disturbing while not being in the classic horror mold. It represents my first attempt at a comprehensive landscape painting, too. I started with a simple graduation of color that increased in saturation from back to front. This formed the basis of the atmospheric haze that would create depth to the image. I blocked in the darker shapes of the trees and cliffs with a large square brush, color-picking from the image rather than the palette to get the right tone and hue (I rarely go back to the palette once the initial colors are down—this helps to provide cohesion and to prevent compartmentalized coloring). Once I had the general composition, I sketched in the skulls and the people, and then worked with smaller and smaller brushes, refining detail until it was complete."

ARTIST **SIMON DOMINIC** SOFTWARE **PAINTER**

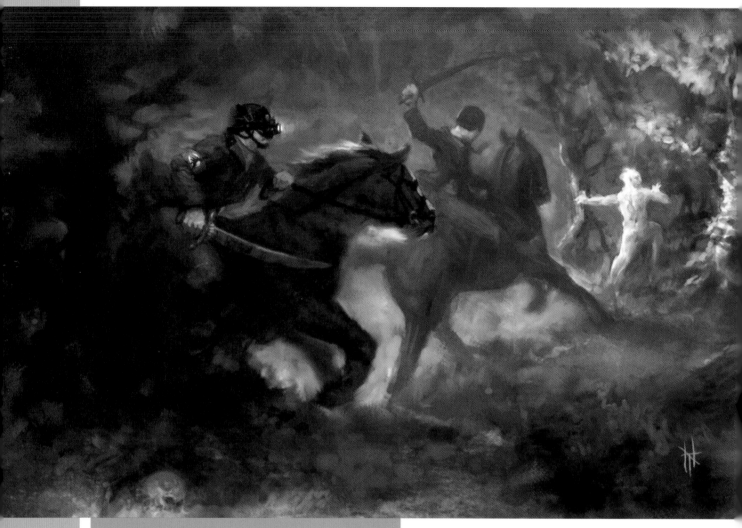

Most Noble Fellowship of Artemis

This fluid composition is more about movement than detail, and it draws the viewer's attention to the pale figure trying to escape the hunting party. The way the fleeing figure is illuminated leaves us no option but to share the hunters' focus of attention.

ARTIST **TORSTEIN NORDSTRAND** SOFTWARE **PHOTOSHOP**

Holy anger

Storm clouds form a furious presence over the badlands. The face's Meso-American features evoke connection with dispossessed Indian deities and the desecration of the landscape by the 1950s atomic bomb tests. The cruciform posts are a recurring motif in Grzegorz's landscapes and here could be totem poles, telegraph poles, or signposts.

ARTIST GRZEGORZ KMIN SOFTWARE PHOTOSHOP

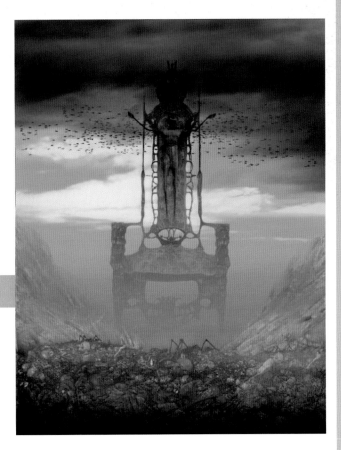

Naked King

A colossal throne stands abandoned in a carrion-strewn landscape glimpsed through the mists of immemorial time. Crows circle, waiting until some unseen danger has passed, before descending to feed on the scraps that litter the plain—remnants of a million genocides.

ARTIST GRZEGORZ KMIN SOFTWARE PHOTOSHOP, POSER

5

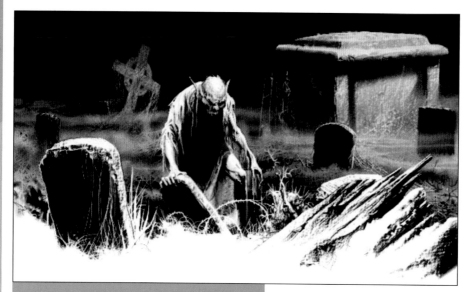

FIEND IN CEMETERY

A chiaroscuro drawing of a night-time graveyard effectively captures the play of moonlight over a nocturnal setting. Nick explains further: "This was one of my first digital pieces. I created it in Art Dabbler, a great little starter program which came bundled with a small Aiptek graphics tablet. I did it all on one layer (all that is available in the program) using the *Lasso* tool to mask out areas to work within, and utilizing Dabbler's wide range of paper textures. I painted the black using the *Pen* tools, then applied lighter tones using the *Chalk* tools."

ARTIST **NICK HARRIS** SOFTWARE **ART DABBLER**

FLORIST

Here is a sepulchral scene with a touch of graveyard humor. Grzegorz has used a very bleak, monochromatic palette with just one spot of desaturated red. The flowers are like the etiolated flower-seller herself, clinging to life on the edge of a landscape of death.

ARTIST **GRZEGORZ KMIN** SOFTWARE **PHOTOSHOP, POSER**

GRAVE WATCHER

This tangled, undead form, as though risen from the earth, loosely references the Sedlec Ossuary in the Czech Republic, a macabre chapel decorated with human bones.

ARTIST GRZEGORZ KMIN
SOFTWARE PHOTOSHOP, POSER

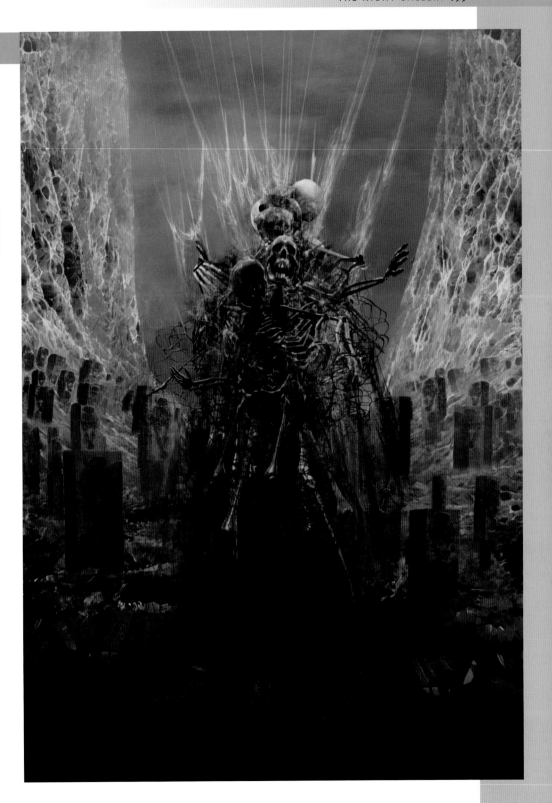

GLOSSARY

16-BIT COLOR

A facility in image-editing applications that allows you to work on images in 16-bit-per-channel mode, rather than eight, resulting in finer control over color, but larger file sizes. An RGB image would total 48 bits (16 x 3) and a CMYK image, 64 bits (16 x 4).

24-BIT COLOR

Allocating 24 bits of memory to each pixel, giving a screen display of 16.7 million colors (a row of 24 bits can be written in 16.7 million different combinations of 1s and 0s), sometimes called true-color. Twenty-four bits are required for CMYK separations (eight bits for each).

ALPHA CHANNEL

Pixel channel used to store data such as mask or transparency information. Appears as a separate grayscale channel, which accompanies any image file and determines which parts of the final image are affected.

ALPHA MAP / ALPHA BLENDING

An extra value added to the pixels of a texture map to create transparency, making it possible to see through objects or effects like glass and water.

BITMAP

The main method used to store and display digital images on computer, with the picture stored as a grid of differently colored pixels. When viewed at an appropriate size, the pixel patterns resemble a continuous tonal image.

BLENDING MODE

The method used by an image-editing application to control the interaction between a layer and the layer below it. As different blending modes allow complex interactions of light, tone and color, blending modes can be used to create a range of interesting effects.

BLINN SHADER

A rendering shader that has reflectivity and shiny controls useful for materials such as glass, metal, and plastic.

BMP

Windows file format for bitmapped or pixel-based images.

BUMP MAP

A surface material that adds "bump" or depth detail to the surface of a model without actually affecting its geometry.

BURN

A technique which has transferred from photography to many 2D image-editing applications. When applied, it darkens parts of the image.

CLIPPING

Limiting an image or a piece of art to within the bounds of a particular area.

CMYK (CYAN, MAGENTA, YELLOW, AND KEY PLATE)

The four-color printing process based on the subtractive color model. Black is represented by the letter K, which stands for key plate. In theory, cyan, magenta, and yellow, when combined, form black, but in the printing process this is difficult to achieve economically, hence the additional use of black ink.

COLOR GAMUT / COLOR SPACE

The full range of colors that are achievable by any single device in the reproduction chain. While the color spectrum contains many millions of colors, not all of them are achievable by all devices.

COLOR TEMPERATURE

The temperature—measured in degrees Kelvin—to which a black object would have to be heated to produce a specific color of light.

CURVES

Adjustment parameter in image-editing applications that allows precise control of the entire tonal range of an image.

DENSITY RANGE

The maximum range of tones of an image, measured as the difference between the darkest and lightest tones.

DISPLACEMENT MAP

The type of texture map used in a renderer to deform the surface of a 3D model during rendering.

DODGE

A technique originating in photography which when applied lightens up parts of an image. The *Dodge* tool is found in many 2D image editing applications.

DPI

Dots per inch. The measure of printed resolution.

EXTRUSION

The method of creating a 3D object from a 2D path.

GRAPHICS TABLET

An input device used by most digital artists, consisting of a flat, pressure-sensitive board and stylus, giving the ability to draw onto the screen.

GRAYSCALE

The rendering of an image in a range of 256 levels of gray from white to black.

HIERARCHY

Tree structure listing objects in a scene or materials on an object, in order to display the logical relationships between them.

JPEG / JPG

Joint Photographic Expert Group. The international standards organization, which created the widely used lossy compression image file format of the same name.

LAYERS

Used in many software applications, layers allow you to work on one element of an image without disturbing the others.

LENS EFFECT

3D rendering effects that mimic effects seen in real photographic lenses, such as lens flare.

LEVELS

Adjustment parameter in image-editing applications that allows the user to correct the tonal range and color balance of an image by adjusting intensity levels of the image's shadows, midtones, and highlights.

LOFT(ING)

Lofting is where a surface is applied to a series of profile curves that define a frame.

LOSSLESS COMPRESSION

Methods of file compression in which little or no data is lost.

LOSSY COMPRESSION

File compression where data is irretrievably lost. JPEG is an example of a lossy format.

MASK

A selected portion of an image,

blocked out to protect it from alteration during the painting process.

OBJ

A standard file format created by Wavefront to describe 3D objects. OBJ files can be used within many 3D packages, making it a useful format for cross-application projects.

OMNI LIGHT

Illumination source that points in all directions.

PERSPECTIVE

A technique of rendering 3D objects on a 2D plane, by giving the impression of an object's relative position and size when viewed from a particular point.

PIXEL

A contraction of "picture element." The smallest component of any digitally generated image, such as a single dot of light on a computer screen. In its simplest form, one pixel corresponds to a single bit: 0 = off, or white; 1 = on, or black. In color or grayscale images, one pixel may correspond to up to 24 bits.

POLYGON

The building blocks of 3D on a computer. A number of connected points that together create a shape or face. Polygonal meshes are created from joining these faces together. These meshes then form geometric shapes.

POLYGROUP

A way to select and isolate sections of a 3D model to facilitate easier modeling or control effects.

PRIMITIVES

Simple geometrical objects in 3D applications such as spheres, cubes, and cylinders, which are combined together or deformed to create more complex shapes.

PSD

Stands for Photoshop Document. Image format for files created using Adobe Photoshop.

RADIOSITY

A lighting effect used in rendering that realistically calculates the cumulative effect of light reflecting from different surfaces.

RAY TRACING

Rendering procedure that sends out hypothetical rays of light originating from the objects in a scene in order to determine the appearance of each pixel that will appear in the final image.

REFLECTION MAP

A surface material that is used to determine what is reflected in an object's surface.

RENDER / RENDERING

The application of textures and lighting, which together transform a collection of objects into a realistic scene. All of the data in the 3D scene—the location and nature of all light sources, locations and shape of all geometry, and also the location and orientation of the camera through which that scene is viewed—are collected to create a fully realized 2D image.

RESOLUTION

The number of pixels in a screen bitmap image (or dots on a printed image) contained within a given surface area, usually stated in pixels or dots per inch. This resolution effectively acts as a measure of the detail contained in an image, and also defines how much the image can be blown up or zoomed into before the pixels become apparent.

RGB (RED, GREEN, BLUE)

The colors of the additive color model, used on monitors and Web graphics.

SHADERS

Shaders determine the appearance of an object. These are layers of attributes that make up how the surface of the model reacts to light, color, reflectivity, appearance and so on.

SMOOTHING

In drawing and 3D applications, smoothing is the refinement of paths or polygons.

SOFT SELECTION

Manipulation of a mesh *(see Wireframe)* using tools that give soft, organic, 3D curves.

SPECULAR

The "highlight value" of a shiny object, also commonly used in the creation of specular maps.

SPLINE

An editable curve used to define the shape of a 3D model.

SPOTLIGHT

Illumination from a single source in one specific direction, along a cone-shaped path.

SUBDIVISION SURFACES

Geometric surface type used for modeling organic objects. Usually built from a polygonal mesh.

TEXTURE MAP

A 2D image (such as a JPG image) used as a shader. Texture maps are applied to the surface of a 3D object in order to give it extra detail, such as scratches and patterns. They can be created inside the 3D application using procedural methods or imported as 2D bitmapped images (file textures) from a digital photo.

TIFF OR TIF

Tagged Image File Format. A standard and popular graphics format used for scanned, high-resolution bitmapped images and color separations.

TRANSFORM / FREE TRANSFORM

Enables the dragging and stretching of a selection in an image-editing program, allowing the area to be re-sized, skewed, distorted, rotated, flipped horizontally or vertically, and have perspective applied.

TRANSPARENCY MAP

Surface material that determines what is reflected in a transparent object's surface.

UV CO-ORDINATES

The vertex co-ordinates of a model that define the surface parameters of an object and therefore enable artists to accurately place parts of an image onto the correct place. *(See texture mapping)*

UV MAPPING

A way to add a texture map to a 3D polygonal model using the UV co-ordinates.

VERTEX

A control point on a path. Often shortened to "vert."

WIREFRAME

A 3D object viewed as a polygonal mesh with no "surface" or texture applied to it (the object has yet to be rendered). Often used to quickly view a 3D model.

INDEX

ACKNOWLEDGMENTS

A huge thank you to all the artists for their fantastic contributions, enthusiasm, and support.

Special thanks to: Dave & Roz Morris, Leo Hartas, James Wallis, Cat Muir, Nick Harris, Jim Pritchett, Angelo Bod, Alan Buckingham, Iain McCaig, Cristina Chapman, Jamie Wallis, Tom McGuinness and Steve Myers, Mark Green, and Simon Flynn.

Also thanks, for all the years of horror movie sharing and talk of Monsters, to: Dave Carson, Phil Ware, Stephen Witkowski, Steve Laws, Kim Newman, Stephen Jones, Ramsey Campbell, Mike and Jan Wathen, Carl Ford, and Aimee Quickfall.

COPYRIGHT INFORMATION

All artwork is copyright © the individual artists, unless otherwise stated.

Fighting Fantasy™ is a trademark of Steve Jackson and Ian Livingstone. Fighting Fantasy™ is published by Wizard Books, an imprint of Icon Books. www.fightingfantasygamebooks.com

Artwork from the *Call of Cthulhu*™ CCG is copyright © 2006 Fantasy Flight Games, and is used with permission

The Fly in Amber concept images are copyright © 2006 Steve Myers and Tom McGuinness and are used with permission. They cannot be published, transmitted, posted, or otherwise displayed without prior written permission from either Steve Myers or Tom McGuinness

Constantine pre-production artwork is copyright © Tippett Studio. Used with permission

"Soul Skinner" is copyright © Metal Blade Records, Fleshcrawl, and Uwe Jarling

All PlayStation® imagery is copyright © Sony Computer Entertainment Europe

"Shroud of Red" is copyright © Visionary Entertainment. Used with permission

Artwork from the *Vampire*™, *Werewolf*™, and *World of Darkness*™ role-playing games is copyright © White Wolf Game Studio and White Wolf Publishing. Used with permission

Every effort has been made to acknowledge the copyrights and trademarks of parties represented in this book. But errors or omissions may have occurred. For this the author and editors express regret and request corrections for inclusion in subsequent printings, but hereby must disclaim any liability.

IMAGE CREDITS FOR CHAPTER OPENER IMAGES

6–7
"Demon Lover" by Uwe Jarling, www.jarling-arts.com

22–23, 100–101
"The Caretaker" and "Forever Dark" by Tony Hayes, www.tony.hayes@blueyonder.co.uk

60–61
"Fiend" by Tony Hayes, tony.hayes@blueyonder.co.uk

130–131
"When Time is Over" by Grzegorz Kmin, www.aspius-art.pl

GALLERY ARTIST CONTACT DETAILS

Samuel Araya: www.paintagram.com
Angelo Bod: www.angelobod.com
Paul Bourne: www.contestedground.co.uk
Mathew Bradbury: www.bradburyillustration.com
Roberto Campus: www.robertocampus.com
Dave Carson: http://davecarson.topcities.com
Simon Dominic: simon@painterly.co.uk
Jason Felix: www.jasonfelix.com
Mark Gibbons: www.redknuckle.com
Mel Grant: www.melgrant.com
Nick Harris: nickillus@blueyonder.co.uk
Tony Hayes: tony.hayes@blueyonder.co.uk
Frazer Irving: www.frazerirving.com
Grzegorz Kmin: www.aspius-art.pl
Peter Konig: www.peterkonig.com
Ivan Kraljevic: ivo.kraljevic@enter-st.hr
Felipe Machado Franco: http://finalfrontier.thunderblast.net
Torstein Nordstrand: www.torsteinnordstrand.com
Howard Swindell: howard.swindell@btinternet.com
Rob Thomas: www.mindsiphon.com